DOWDLE DOODLES™

CREATIVE COLORING
FOR ALL AGES

NATIONAL
PARKS

{ D·O·W·D·L·E }

Special Thanks to the Dowdle Folk Art Team:
Tony Kemp, Andy Ellis, James Poai, Katie Zubeldia, Hailey Twede, Robert Pierce, Morgan Barksdale, Brittney Hackett, Clara May, Jess Smiley, Brandon Salimbene, David Dean, and Miquelle Buss.

ISBN 978-0-692-61725-0

Printed in U.S.A.

www.dowdlefolkart.com

ENHANCE YOUR EXPERIENCE

You will notice QR codes distributed throughout this book. These codes when scanned will send you to the Dowdle Folk Art web site for a more comprehensive experience with radio shows, videos, and the stories behind the paintings. You'll also find tags to Instagram pages for each coloring book where you can upload an image of the drawings you have colored or view colored pictures from others.

Look for our other great titles of coloring books
coming soon only from Dowdle Folk Art.

Utah • American Cities • Major League Baseball • Canada

ZION NATIONAL PARK

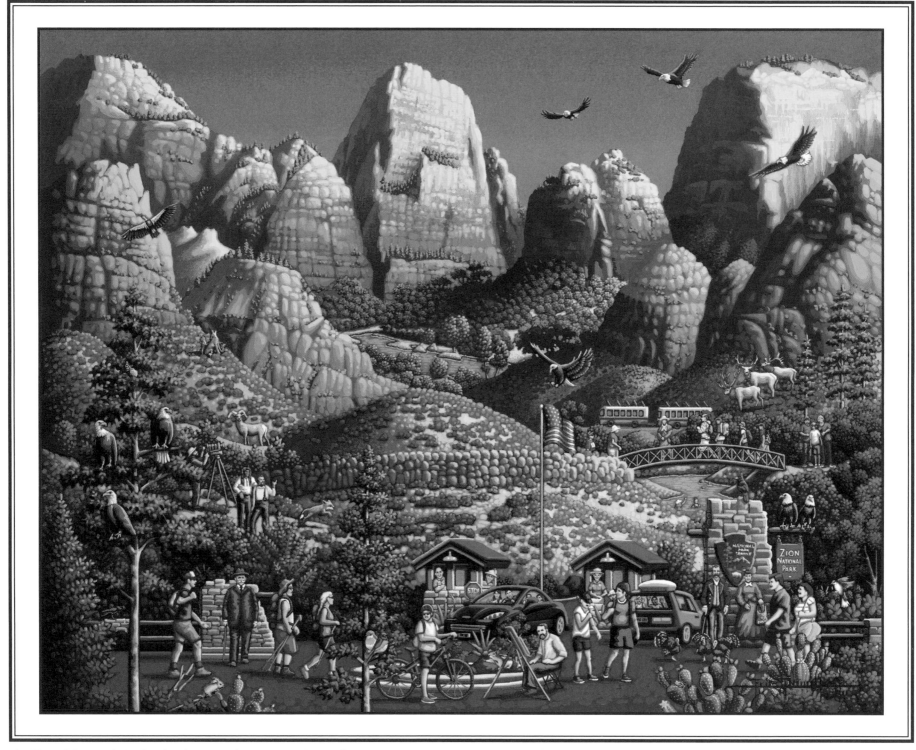

At Zion National Park, the lowest elevation is 3,666 ft (1,117 m) at Coalpits Wash and the highest elevation is 8,726 ft (2,660 m) at Horse Ranch Mountain. One of my all-time favorite artists, Tony Rasmussen, is in this painting. #DowdleNatlParks #ZionNatlPark

Link to the Story, Video, and Radio Show

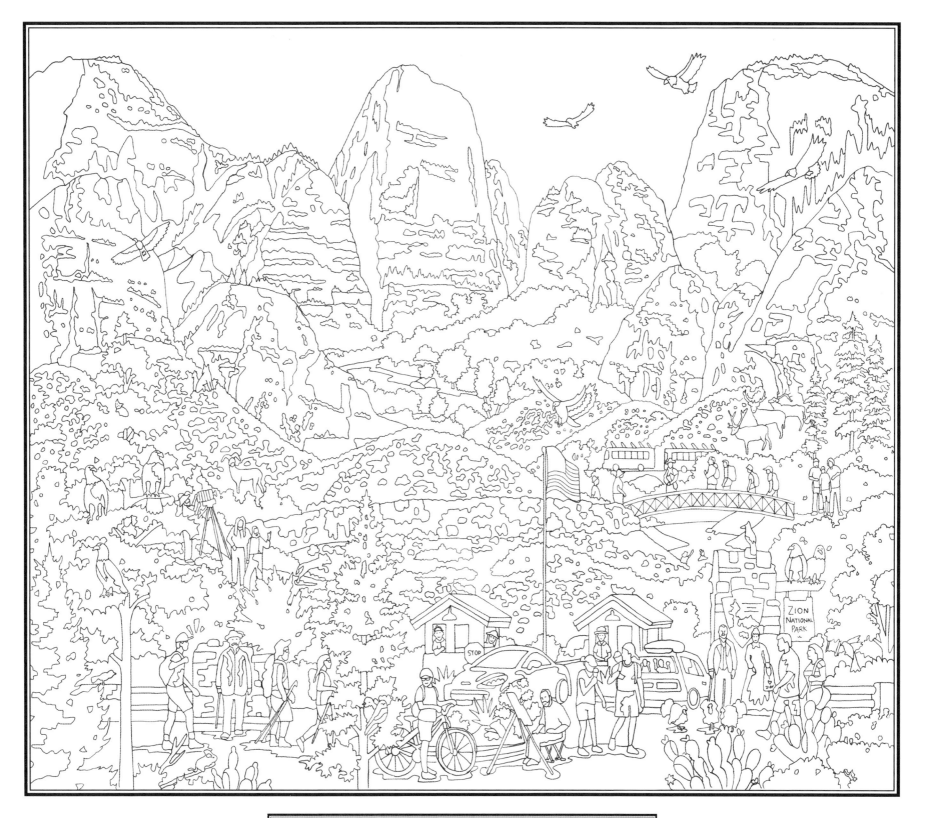

ZION NATIONAL PARK

GREAT WHITE THRONE

Zion National Park is located in the Southwestern United States, near Springdale, Utah. A prominent feature of the 229-square-mile (590 km2) park is Zion Canyon. At 15 miles (24 km) long and up to half a mile (800 m) deep, the canyon cuts through the reddish and tan-colored Navajo Sandstone by the North Fork of the Virgin River. The lowest elevation is 3,666 ft (1,117 m) at Coalpits Wash and the highest elevation is 8,726 ft (2,660 m) at Horse Ranch Mountain. Located at the junction of the Colorado Plateau, Great Basin, and Mojave Desert regions, the park's unique geography provides a diverse environment supporting a variety of unusual plants and animals.

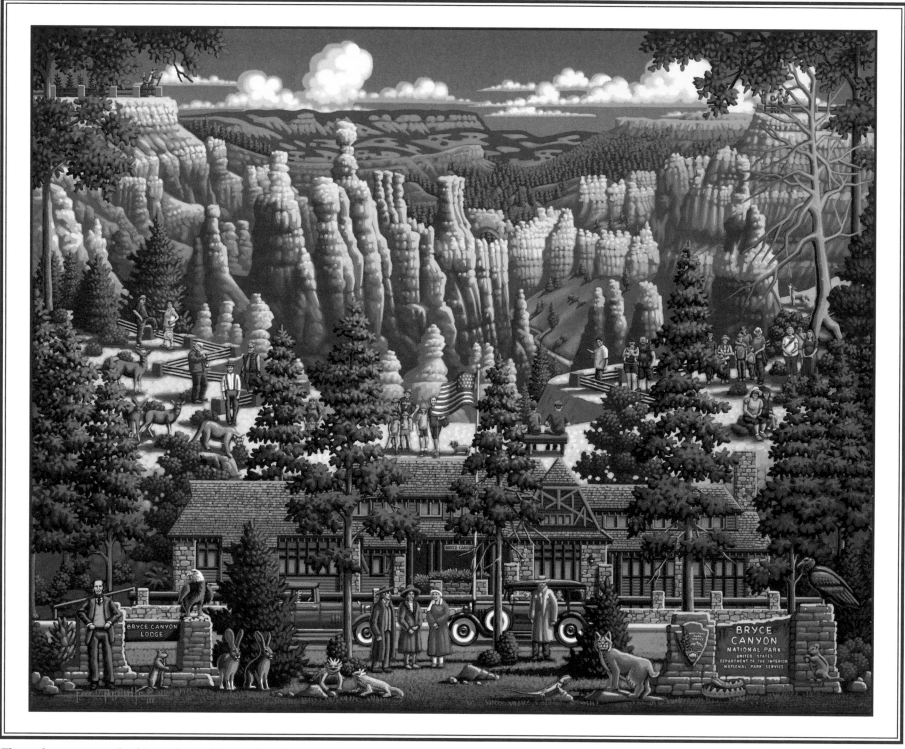

The red, orange, and white colors of the rocks of Bryce Canyon provide spectacular views for park visitors. Bryce sits at a much higher elevation than nearby Zion and varies from 8,000 to 9,000 feet (2,400 to 2,700 m).

Everyone comes to Bryce to see the hoodoos. See if you can find Coyote who turned the ancient Legend People into stone as a curse. #DowdleNatlParks #BryceCanyon

Link to the Story, Video, and Radio Show

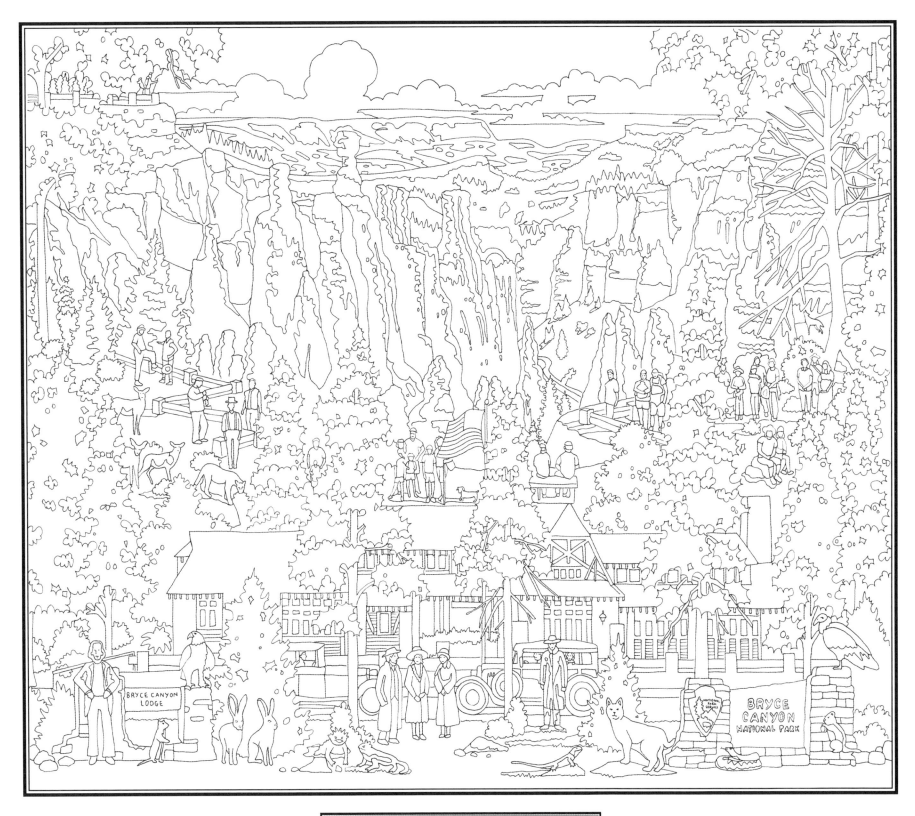

BRYCE CANYON

BRYCE CANYON HOODOOS

Bryce Canyon National Park is located in southwestern Utah in the United States. The major feature of the park is Bryce Canyon, which despite its name, is not a canyon, but instead a collection of giant natural amphitheaters along the eastern side of the Paunsaugunt Plateau. The Bryce Canyon area was settled by Mormon pioneers in the 1850s and was named after Ebenezer Bryce, who homesteaded in the area in 1874. One of the most well-known features of Bryce Canyon are the hoodoos, said by the local Paiute Indians to be the indigenous Ancient Legend People who were turned to stone after displeasing one of their gods, Coyote, saying, "You can see their faces, with paint on them just as they were before they became rocks. The name of that place is Angka-ku-wass-a-wits (red painted faces). This is the story the people tell."

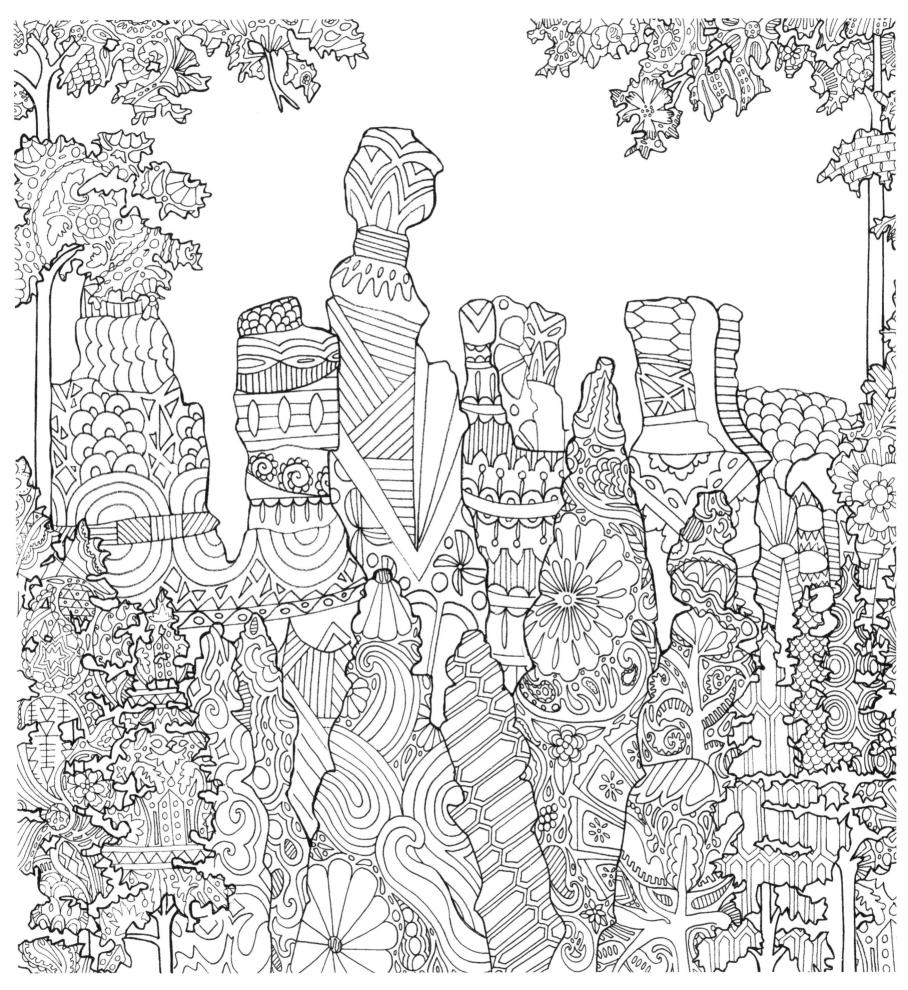

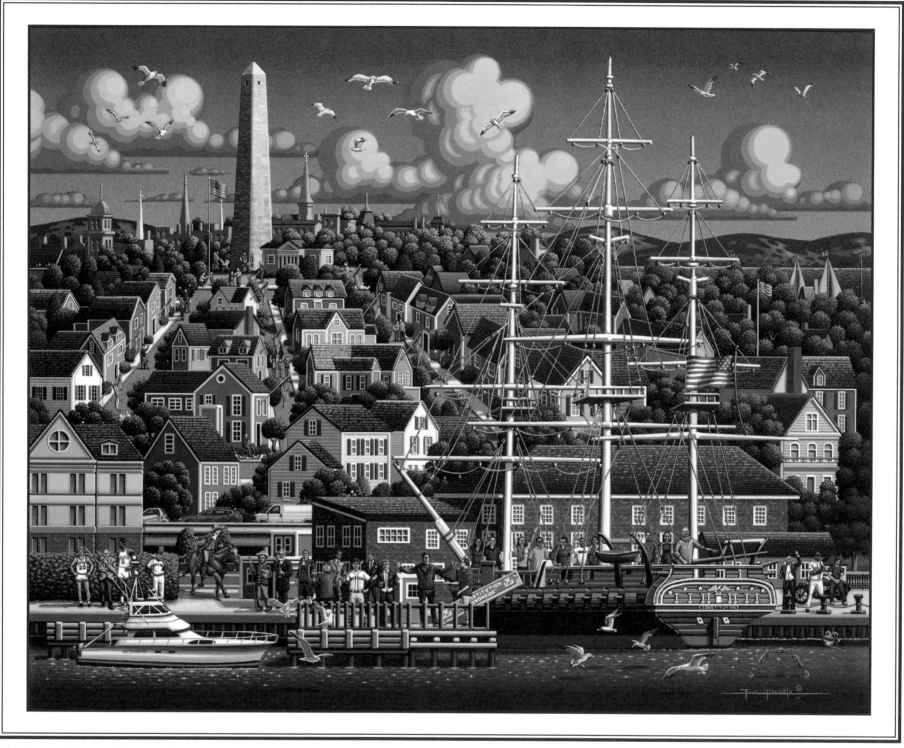

The Boston National Historical Park is an association of sites that showcase Boston's role in the American Revolution. It was designated a national park on October 1, 1974. The park preserves Boston's involvement in the American Revolution and the establishment of one of the first United States Navy yards. #DowdleNatlParks #BostonHistorical

Link to the Story, Video, and Radio Show

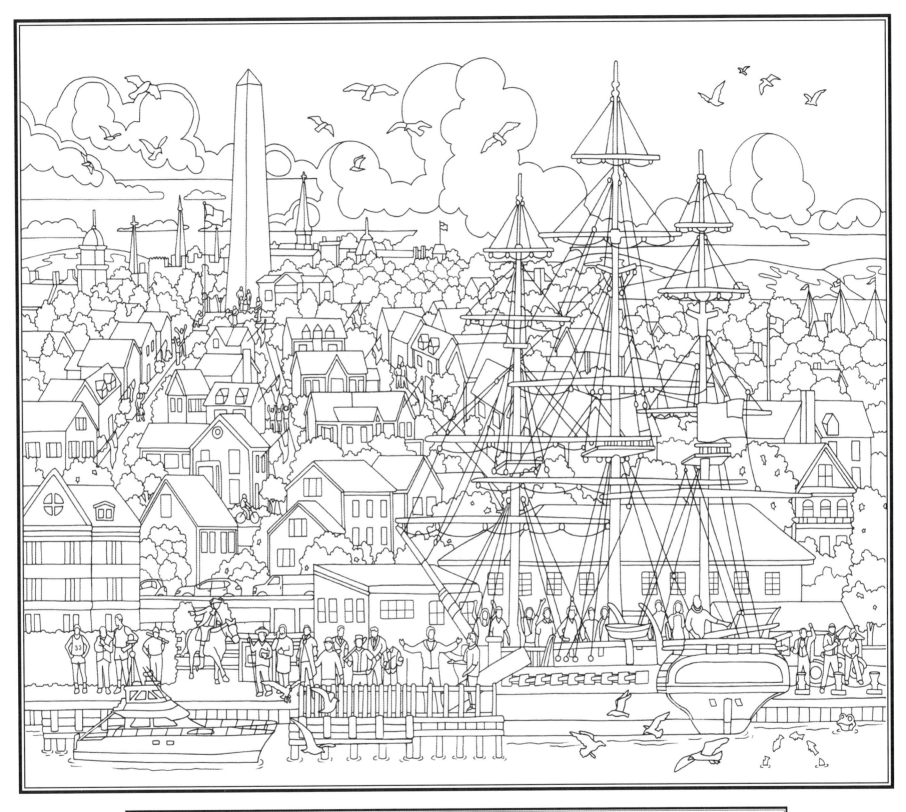

BOSTON NATIONAL HISTORICAL PARK

GRAND CANYON

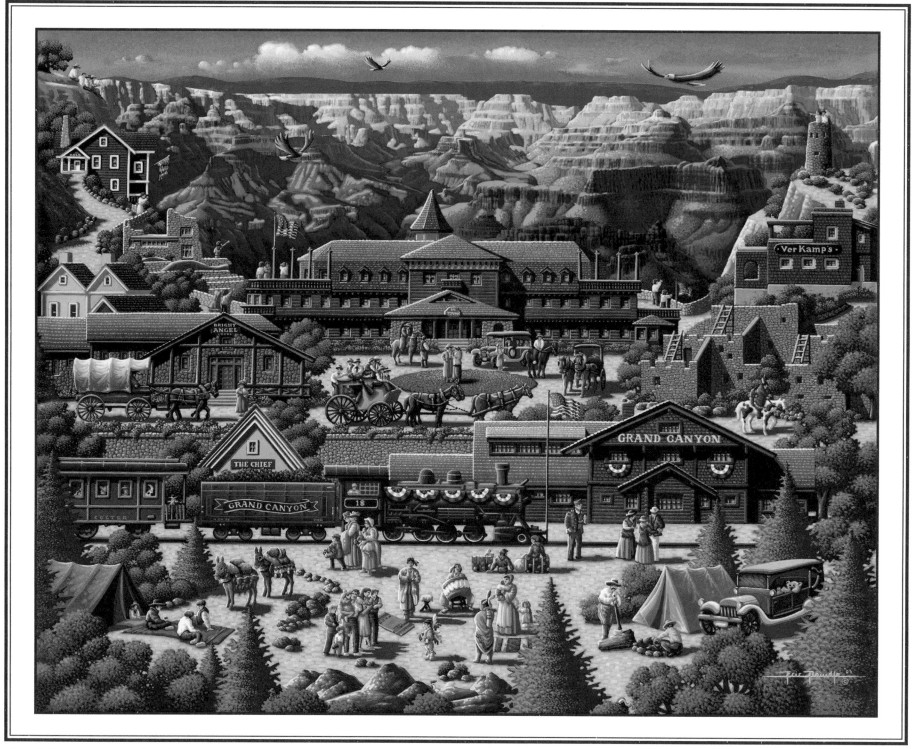

Grand Canyon National Park is the 15th oldest park in the United States. Located in northwestern Arizona, the park's central feature is the Grand Canyon, a gorge of the Colorado River. The Grand Canyon is considered one of the Seven Natural Wonders of the World. #DowdleNatlParks #GrandCanyon

Link to the Story, Video, and Radio Show

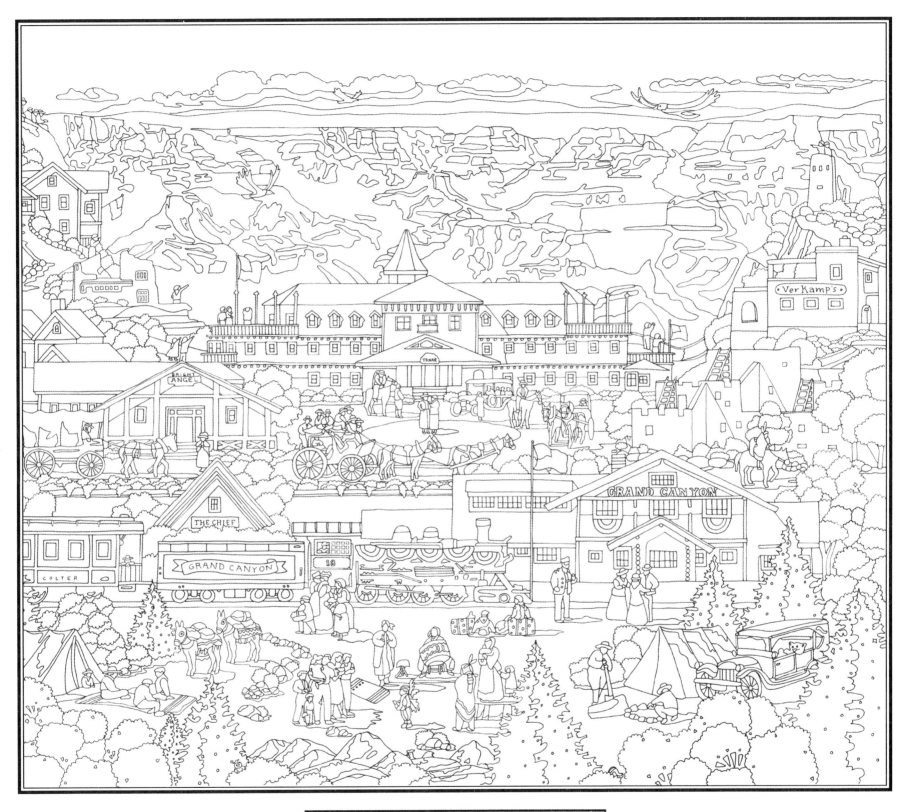

GRAND CANYON

GRAND CANYON

The Grand Canyon is one of the world's biggest and most well known natural wonders. As visitors perch along the edge of its steep, towering cliffs, one can't help but stand in awe of its majestic size and the geologic age required to create such an iconic sight. The mighty copper-colored Colorado River has carved its way through layers of rock as it has meandered along over eons of time. Cutting inch by inch, the canyon now stretches 277 miles long, reaches about 1 mile deep, and spans an average of 10 miles wide (18 miles at its widest). And it seems this great granddaddy is getting older and older. It is now estimated that the Grand Canyon formed some 17 million years ago, whereas it was previously thought to be only 4-6 million years old. Now, either way, that's a lot of birthday candles to put on a cake!

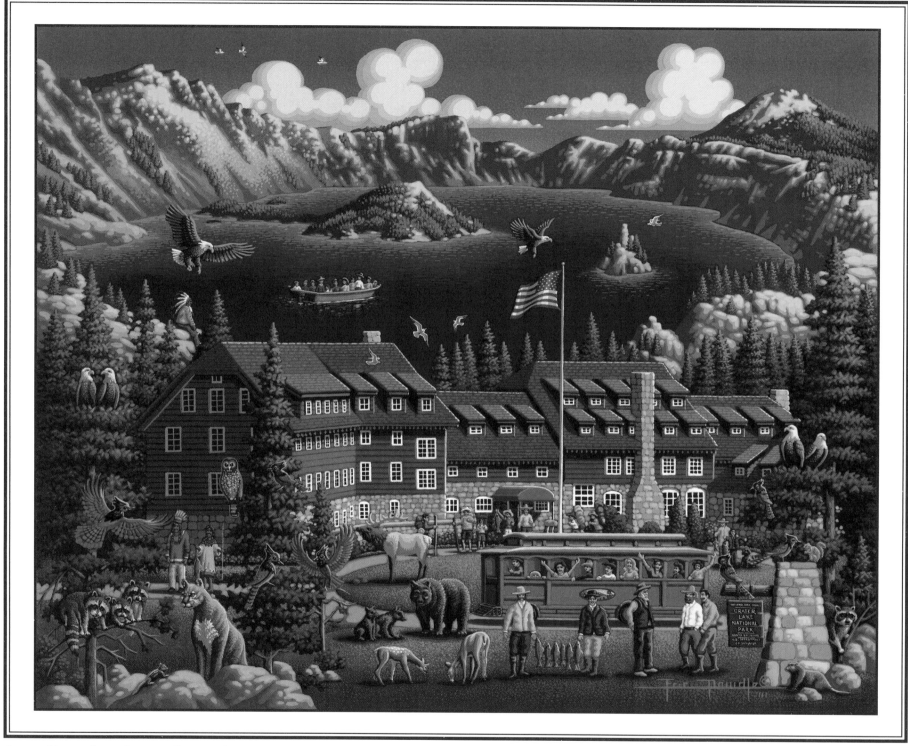

Located in southern Oregon, Crater Lake National Park was established in 1902 and is the sixth oldest national park in the United States and the only national park in Oregon. The lake is 1,943 feet deep at its deepest point, making it the deepest lake in the United States, the second deepest in North America, and the ninth deepest in the world. #DowdleNatlParks #CraterLake

Link to the Story, Video, and Radio Show

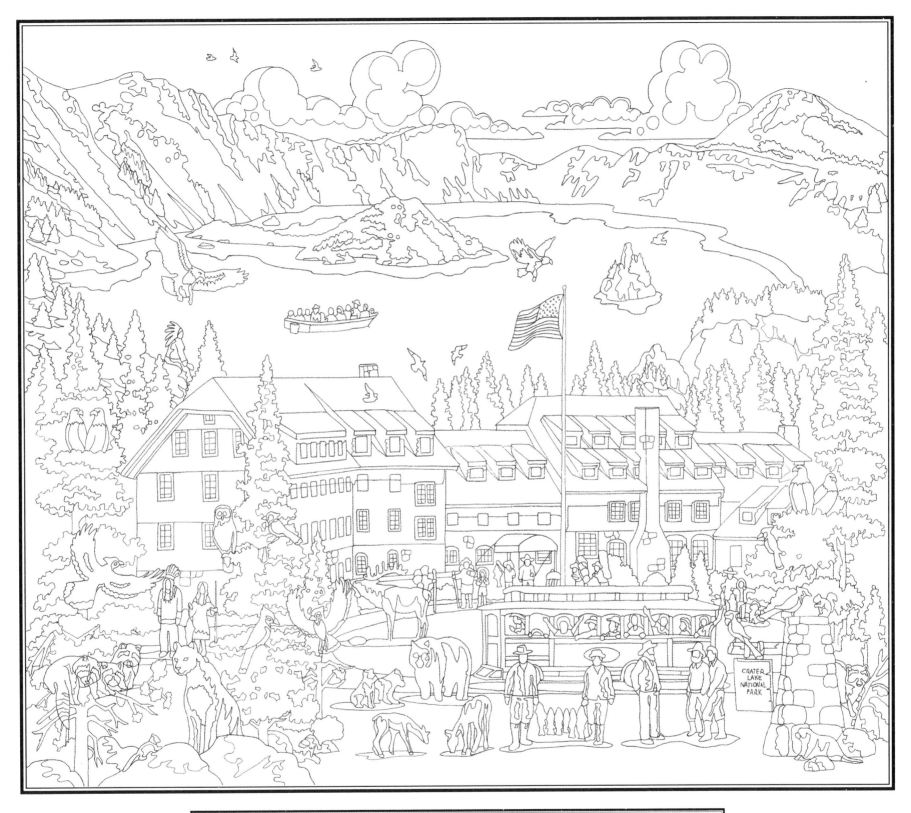

CRATER LAKE NATIONAL PARK

GLACIER NATIONAL PARK

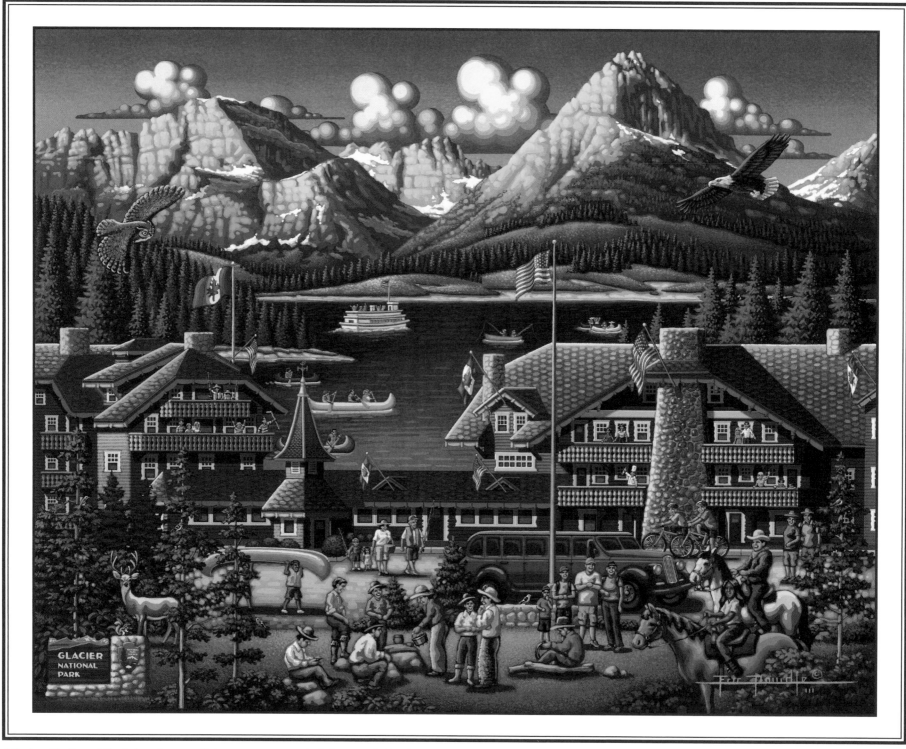

Glacier National Park is a large wilderness area up in Montana's Rocky Mountains. It has glacier-carved peaks and valleys running up to the Canadian border. The park contains more than 700 miles of hiking trails and a route to the photogenic Hidden Lake. Many who go to the park enjoy backpacking, cycling, and camping. While there, one can see diverse wildlife ranging from mountain goats to grizzly bears. #DowdleNatlParks #GlacierNatlPark

Link to the Story, Video, and Radio Show

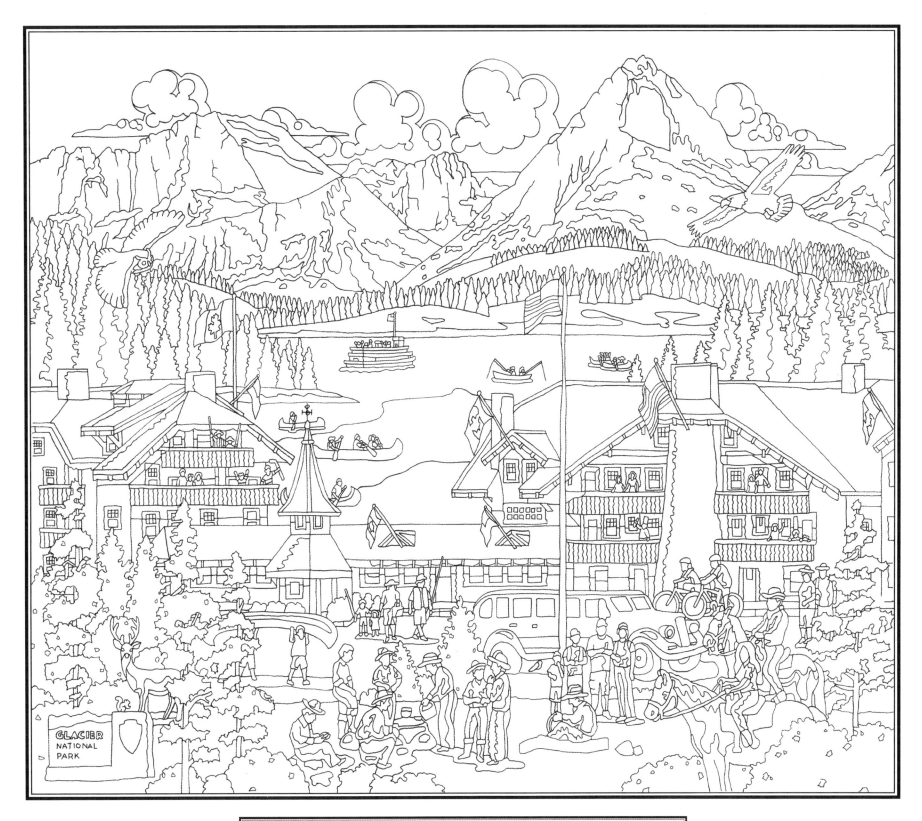

❊ GLACIER NATIONAL PARK ❊

GLACIER NATIONAL PARK

Established in 1910, Glacier National Park is a treasure—a real gem in the crown of the National Parks. Taking in the one million acres is an experience of pure bliss. From breathtaking mountain vistas, to fresh carved valleys, pristine lakes and waterfalls, abundant wildlife, and yes, 25 glaciers, one feels like drinking in the clarity of the moment and never wanting to leave. The world famous Going-to-the-Sun Road travels directly into the heart of park, crossing the Continental Divide through Logan's pass which gets up to 80 feet of snow each winter. Not to worry however. It normally takes just over 10 weeks to plow the road free of snow before the summer season comes!

GLACIER NATIONAL PARK

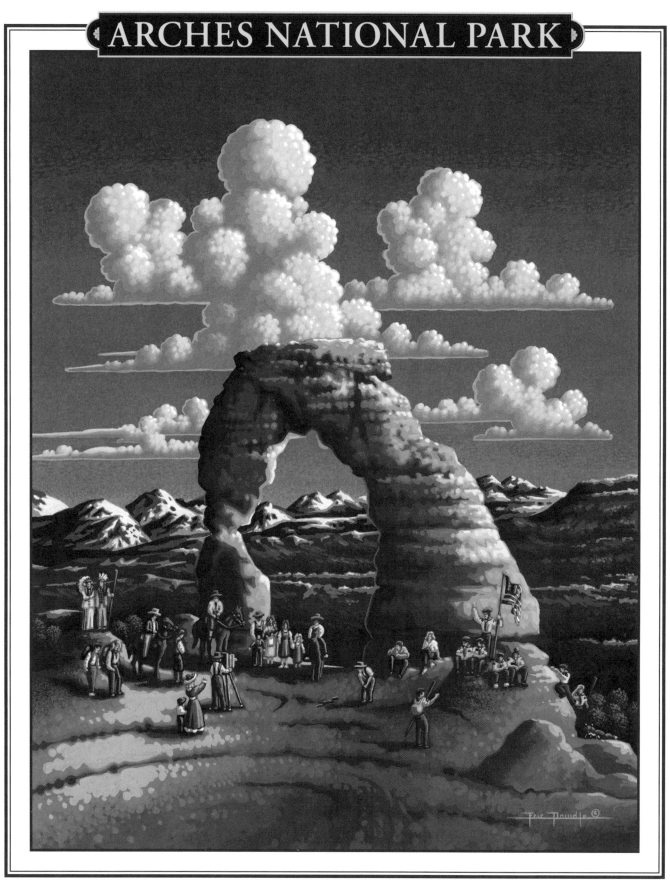

One of the most widely recognized landmarks in Arches National Park is Delicate Arch. When the Olympics were held in Salt Lake City in 2002, the Olympic torch relay passed through the arch. #DowdleNatlParks #DelicateArch

Link to the Story, Video, and Radio Show

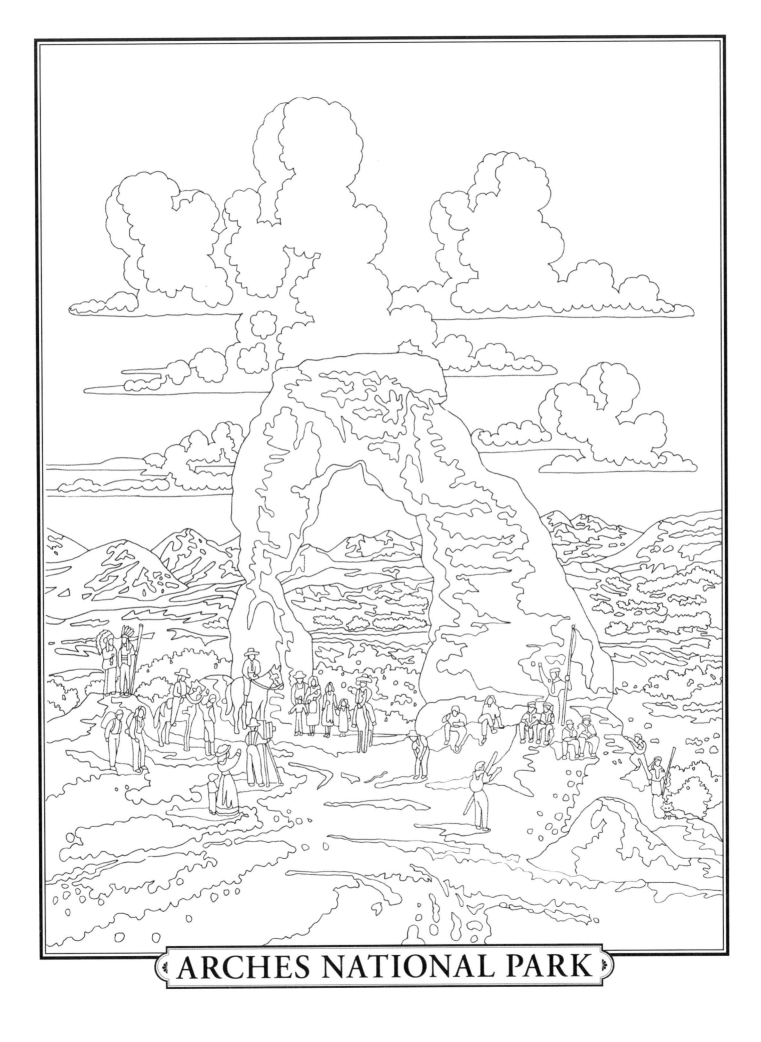

ARCHES NATIONAL PARK

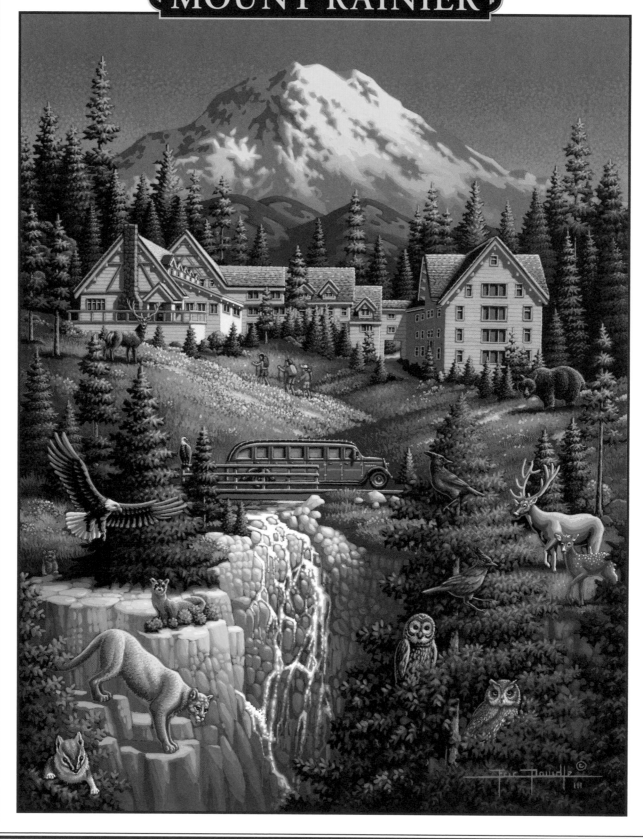

An expansive Washington state reserve southeast of Seattle, Mount Rainier National Park has glacier-capped, 14,410-ft.-high Mount Rainier 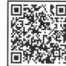 as its towering centerpiece. #DowdleNatlParks #MountRainier

Link to the Story, Video, and Radio Show

MOUNT RAINIER

MOUNT RAINIER

The mighty Mount Rainier, at an elevation of 14,410 feet, is the world's 21st most prominent mountain and the highest in the lower 48 states. Standing on the summit, one can see other mountain peaks all the way into Oregon and northern California, including Mount St. Helens, Mount Adams, Mount Baker, Glacier Peak, and Mount Hood. Considered an active volcano, Mount Rainier's last eruption was in 1894, but its many small, high-frequency earthquakes occur as often as five times a day. The surrounding volcanic soil is so fertile that wildflower meadows ring the icy volcano's 25 glaciers and lush ancient forests cloak the lower slopes. With a rich ecosystem that supports abundant wildlife, a world of discovery awaits each outdoor adventurer, young and old. And never mind those rumbling sensations. They are probably just the tingling heartbeats of growing excitement to embrace your wild side.

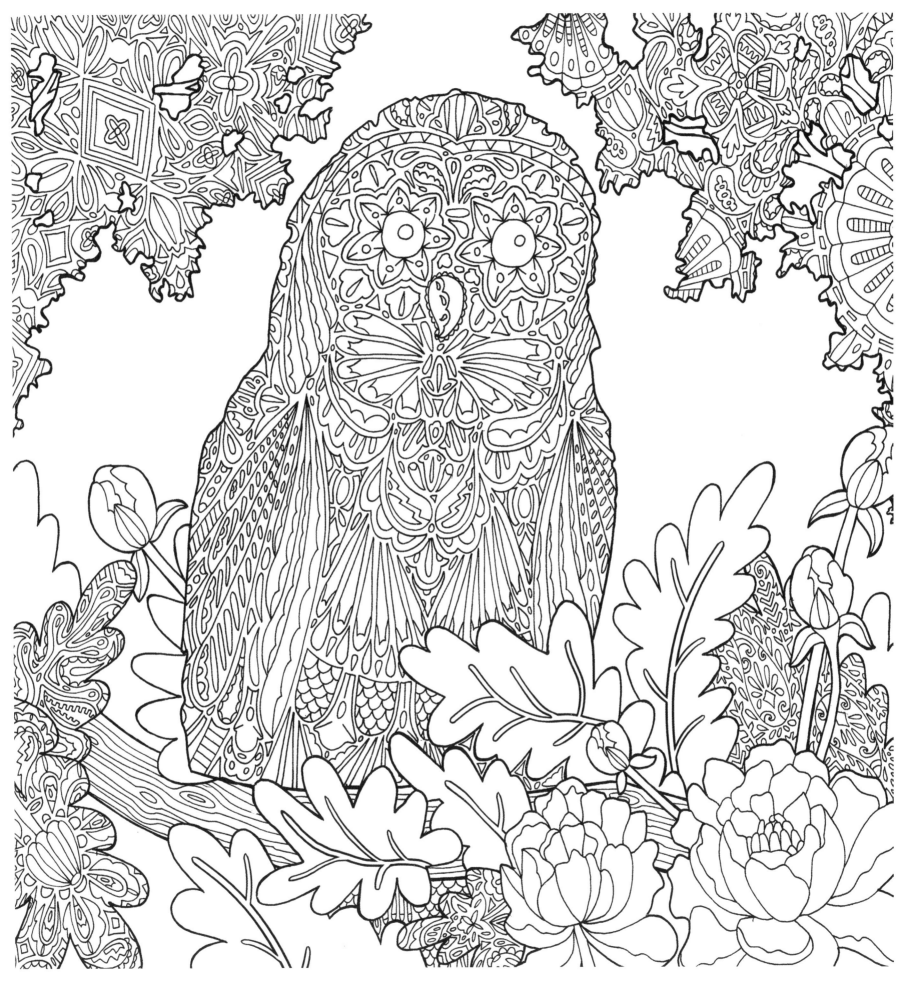

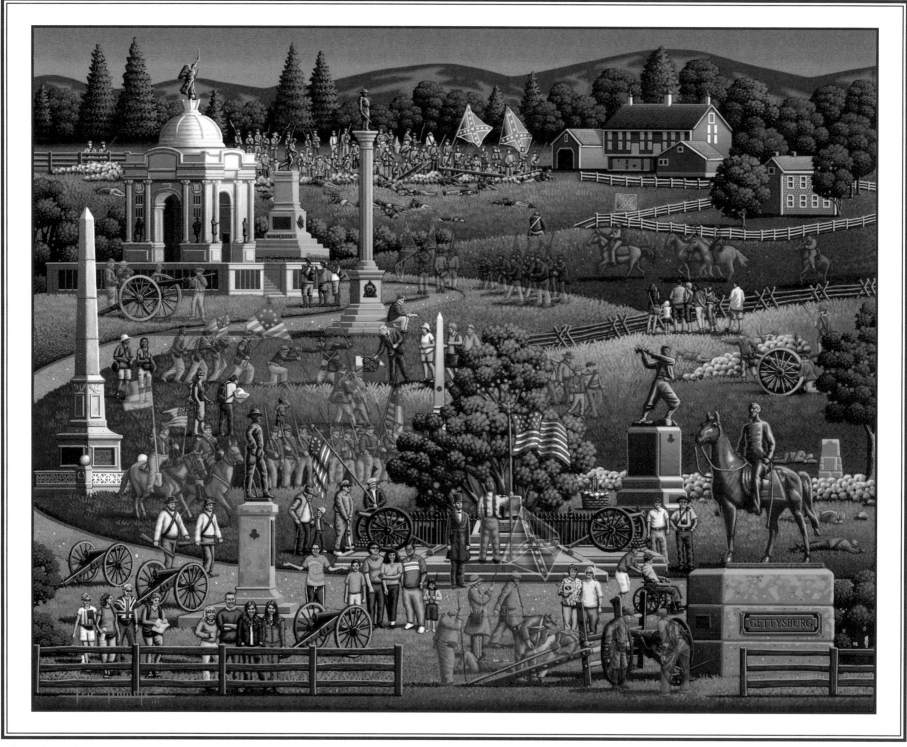

The Gettysburg National Military Park located in Gettysburg, Pennsylvania, protects the landscape of the Battle of Gettysburg in 1863 during the American Civil War. The park has grown more wooded than in 1863, and the National Park Service is working to restore portions of the battlefield to their original non-wooded conditions as well as to replant historic orchards and woodlots that are now missing. #DowdleNatlParks #Gettysburg

Link to the Story, Video, and Radio Show

GETTYSBURG

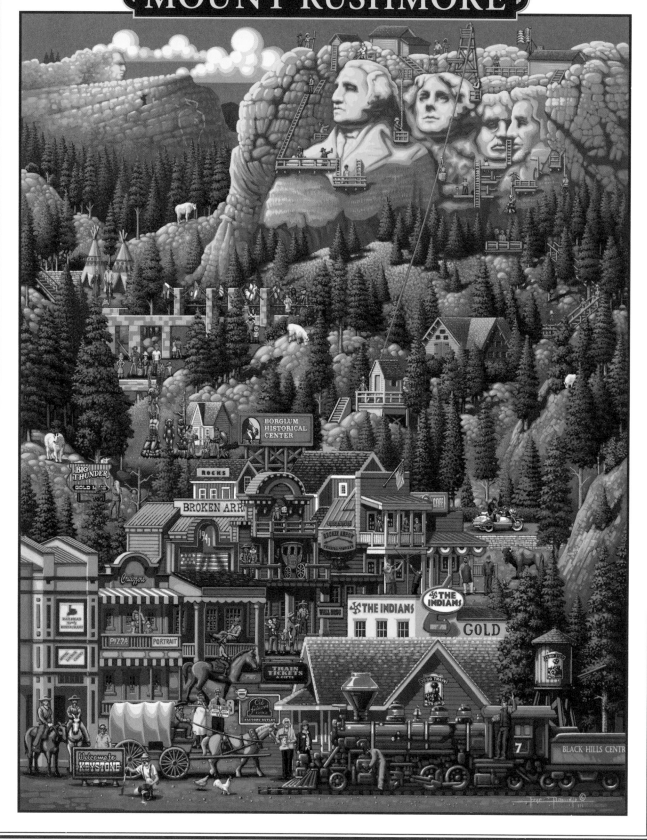

Mount Rushmore National Memorial's 60-ft.-high granite faces depict U.S. presidents George Washington, Thomas Jefferson,

Theodore Roosevelt and Abraham Lincoln. #DowdleNatlParks #MountRushmore

Link to the Story, Video, and Radio Show

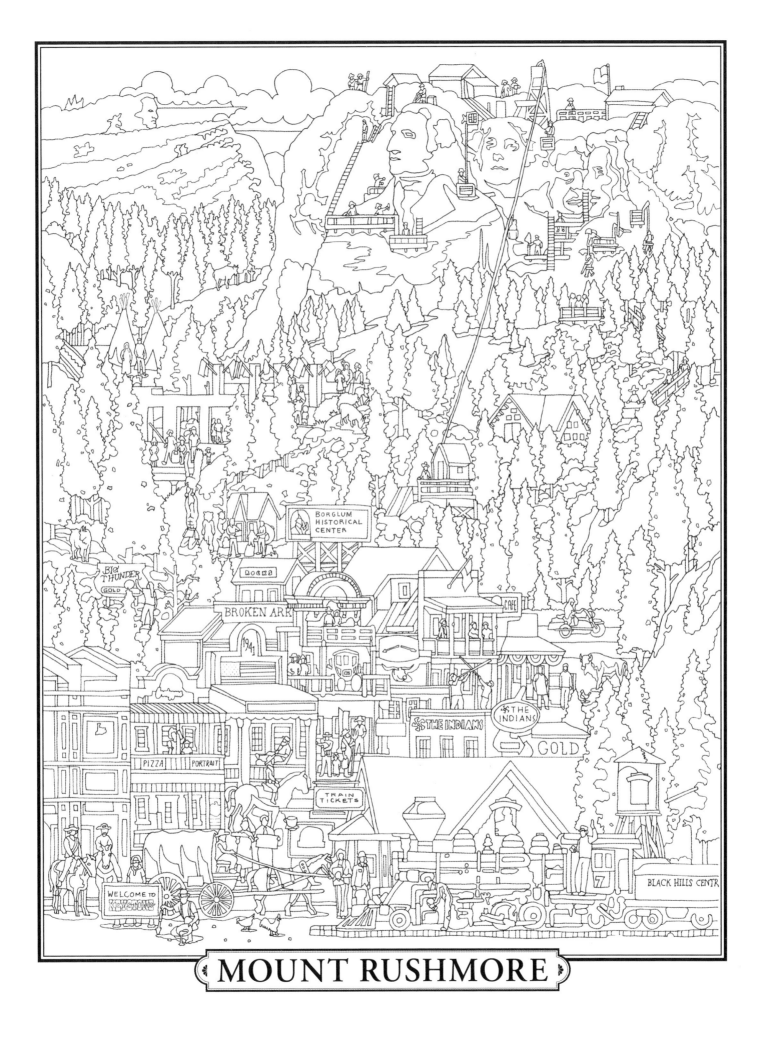

MOUNT RUSHMORE

THE BLACK HILLS

Nestled among the vibrant Black Hills of South Dakota, sits one of the most iconic and recognizable memorials in our nation, the incredible Mount Rushmore. The likenesses of four of our most revered U.S. Presidents are magnificently carved right out of the mountain in tribute to our shared history in the struggle for liberty: George Washington, Thomas Jefferson, Theodore Roosevelt and Abraham Lincoln, which together represent our first 130 years of American history. Each of the President's heads is as tall as a six-story building with a mouth that is 18 feet wide. But there are so many other ways to enjoy your experience exploring in and around the natural surroundings of the park. Immerse yourself in the human history but be sure to embrace the natural outdoor beauty of the Black Hills. Besides, how long can you watch a stiff politician with an 18-foot wide mouth!

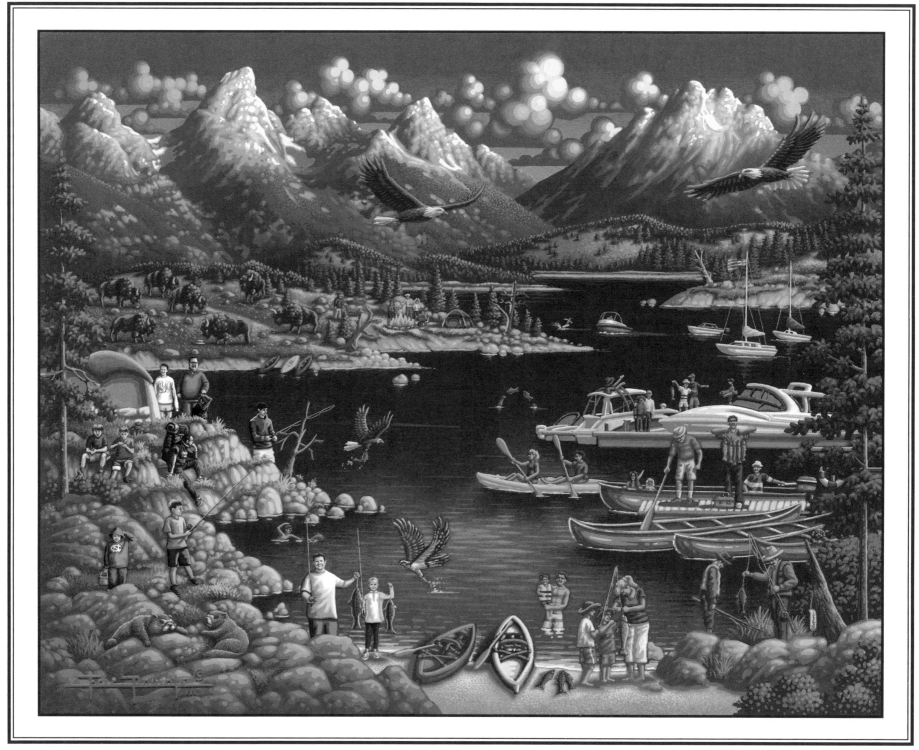

Grand Teton National Park is located in the northwest region of Wyoming. The park encompasses the Teton mountain range, the 4000-meter Grand Teton peak, and the valley known as Jackson Hole. Many go to the park for hiking, mountaineering, backcountry camping, and fishing. It is linked to nearby Yellowstone National Park by the John D. Rockefeller, Jr. Memorial Parkway. #DowdleNatlParks #GrandTeton

Link to the Story, Video, and Radio Show

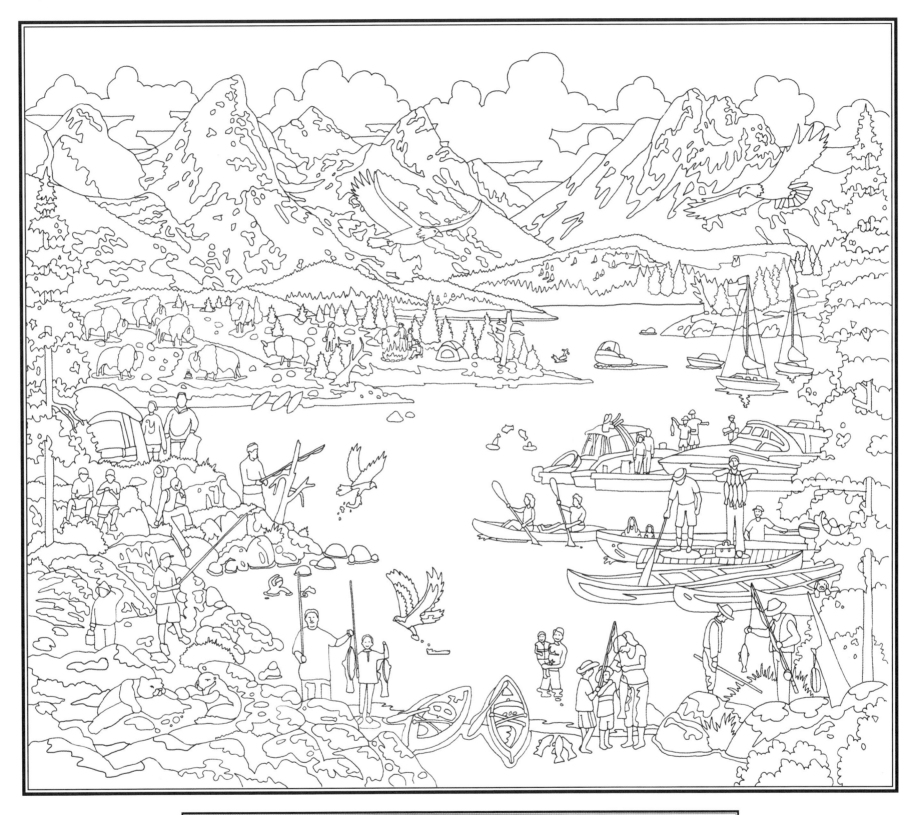

GRAND TETON NATIONAL PARK

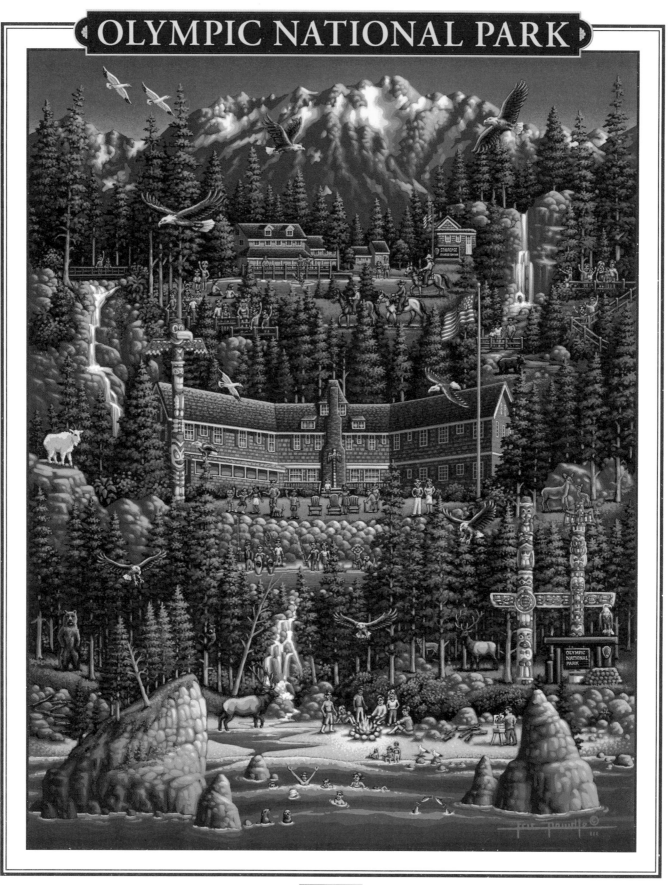

Olympic National Park encompasses many distinctly different ecosystems. Park visitors can experience snow-blanketed mountains, evergreen forests dripping with rain, and ocean beaches pounded by winter storm waves. #DowdleNatlParks #OlympicNatlPark

Link to the Story, Video, and Radio Show

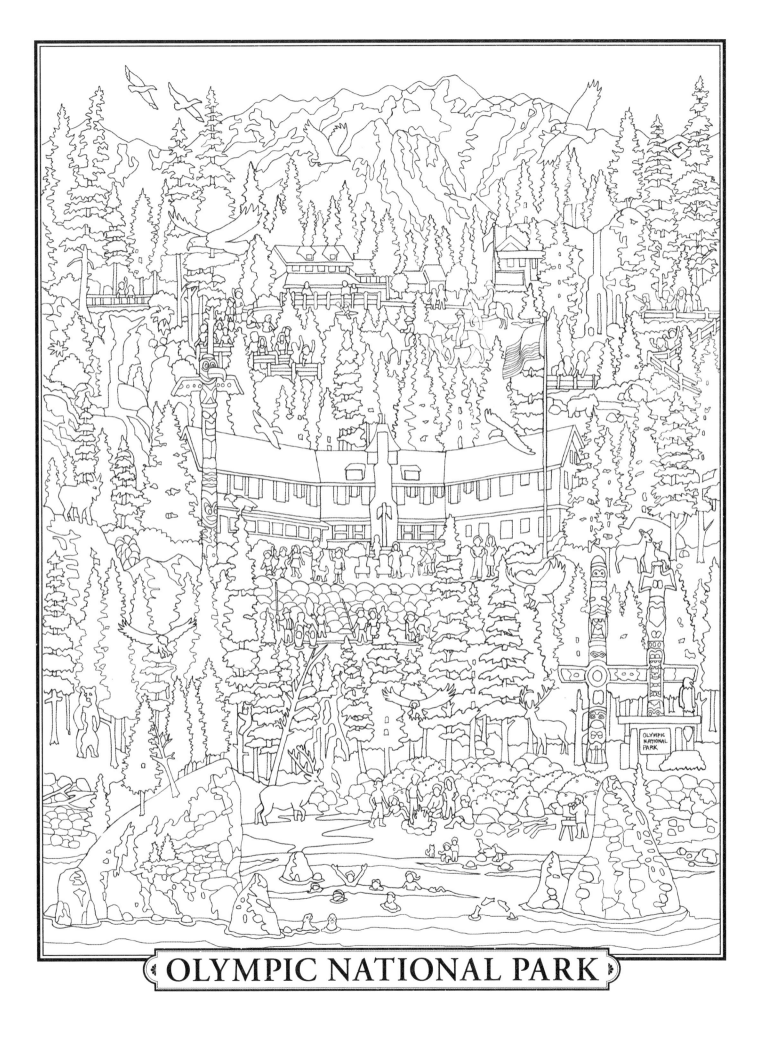

OLYMPIC NATIONAL PARK

MOUNT OLYMPUS

Created in 1938, Olympic National Park covers a massive one million acres and is slightly bigger than the state of Rhode Island. It was named after the tallest peak in western Washington, Mt. Olympus standing at 7,980 feet. Although not as high as other mountains, it has the reputation for being the hardest major peak to climb in the 48 contiguous states. The park boasts a diverse set of ecosystems, ranging from thick, old-growth rain forests punctuated with steep snow slopes and glaciers, to the salty waves crashing ashore along the mighty Pacific Ocean. It's location on the western slopes of the Olympic Mountains can generate upwards 140-179 inches of rain each year in some locations. That's over 12 feet of water! No wonder the lush surroundings beckon to hikers and outdoor enthusiasts of every kind.

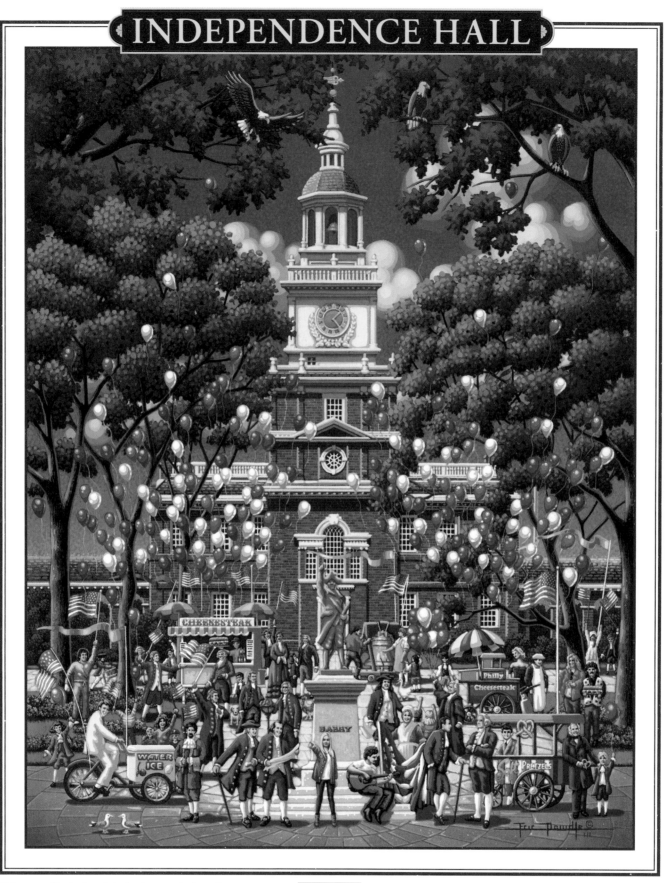

Often called the birthplace of the Constitution, Independence Hall is where both the United States Declaration of Independence and the United States Constitution were debated and adopted. #DowdleNatlParks #IndependenceHall

Link to the Story, Video, and Radio Show

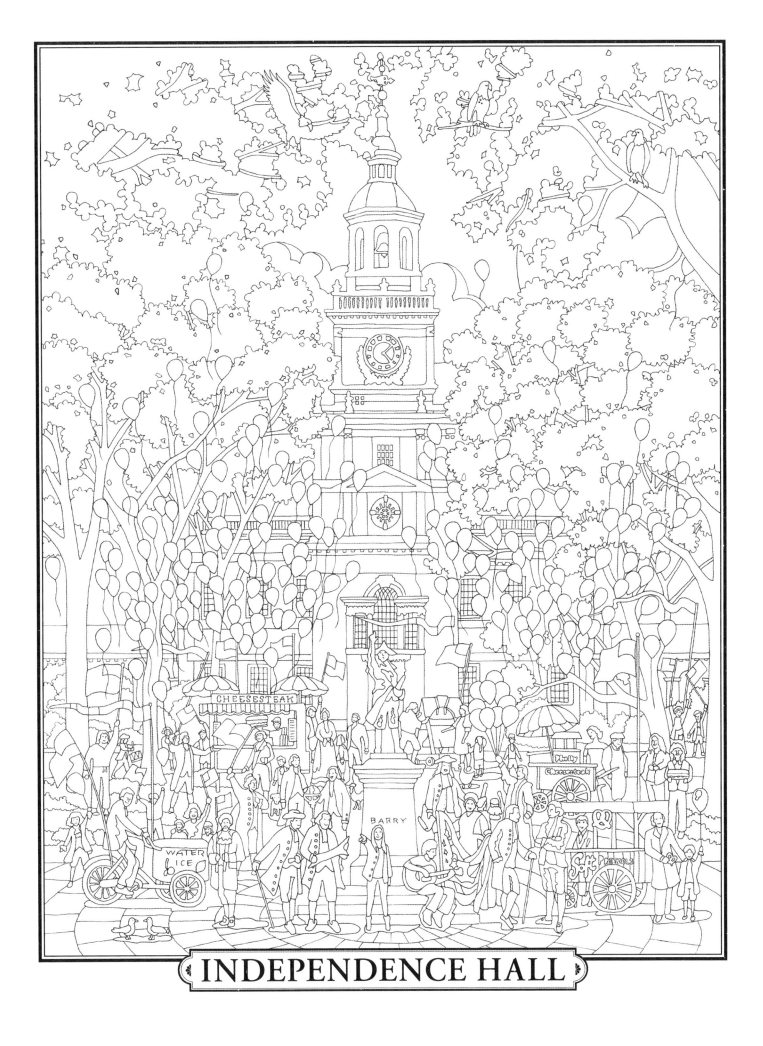

INDEPENDENCE HALL

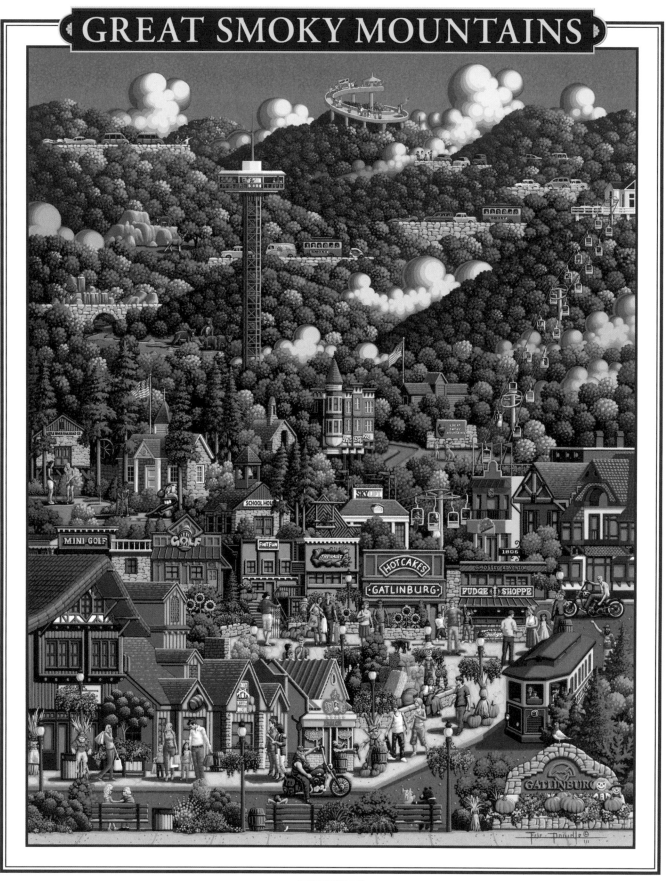

Great Smoky Mountains National Park straddles the border of North Carolina and Tennessee. Streams, rivers and waterfalls appear along hiking

routes that include a segment of the Appalachian Trail. #DowdleNatlParks #SmokyMountain

Link to the Story, Video, and Radio Show

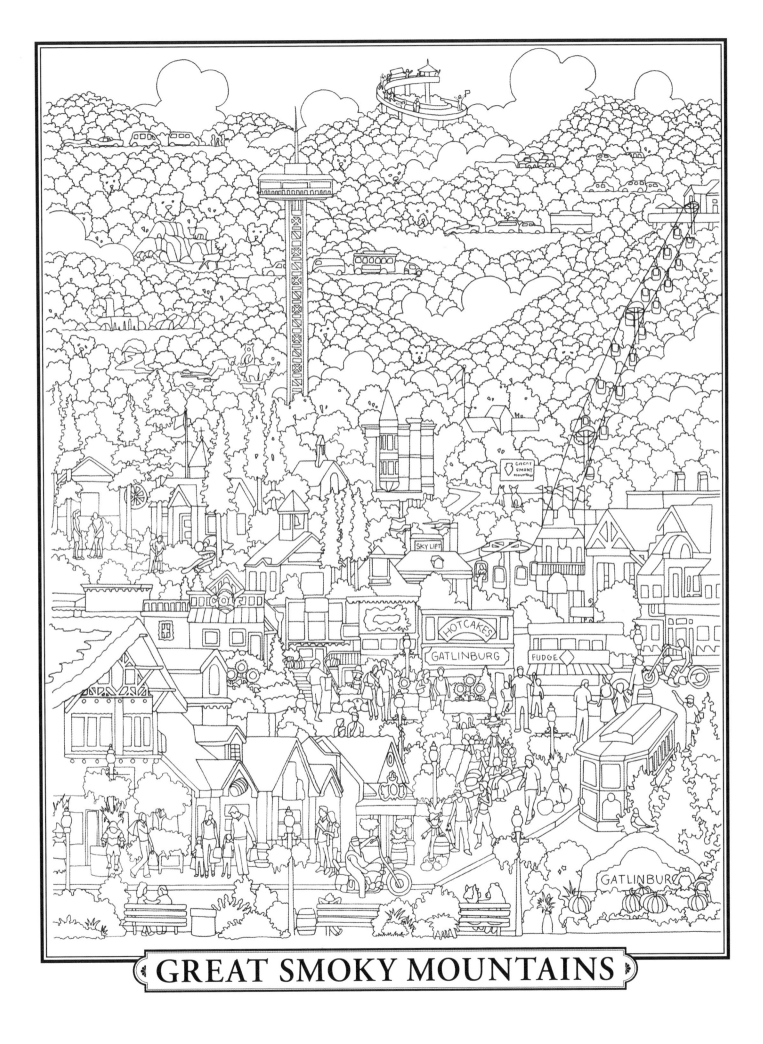

GREAT SMOKY MOUNTAINS

GATLINBURG

Spanning the ridges of Tennessee and North Carolina since 1940, Smoky Mountain National Park covers half a million acres of the Southern Appalachian mountains. Its location and natural beauty make this America's most visited national park. Its bio-diversity contained in its rolling forests is world renown (some say it's considered to be the salamander capital of the world). The park is home to abundant wildlife, with more than 60 types of mammals, including elk, river otters, black bears, and flying squirrels! Hiking and camping enthusiasts are drawn to its over 800 miles of hiking trails, including 70 miles of the historical Appalachian Trail. Nearly 100 historic log buildings have been preserved or restored throughout the park. It's the perfect place to explore the adventurer inside.

GATLINBURG

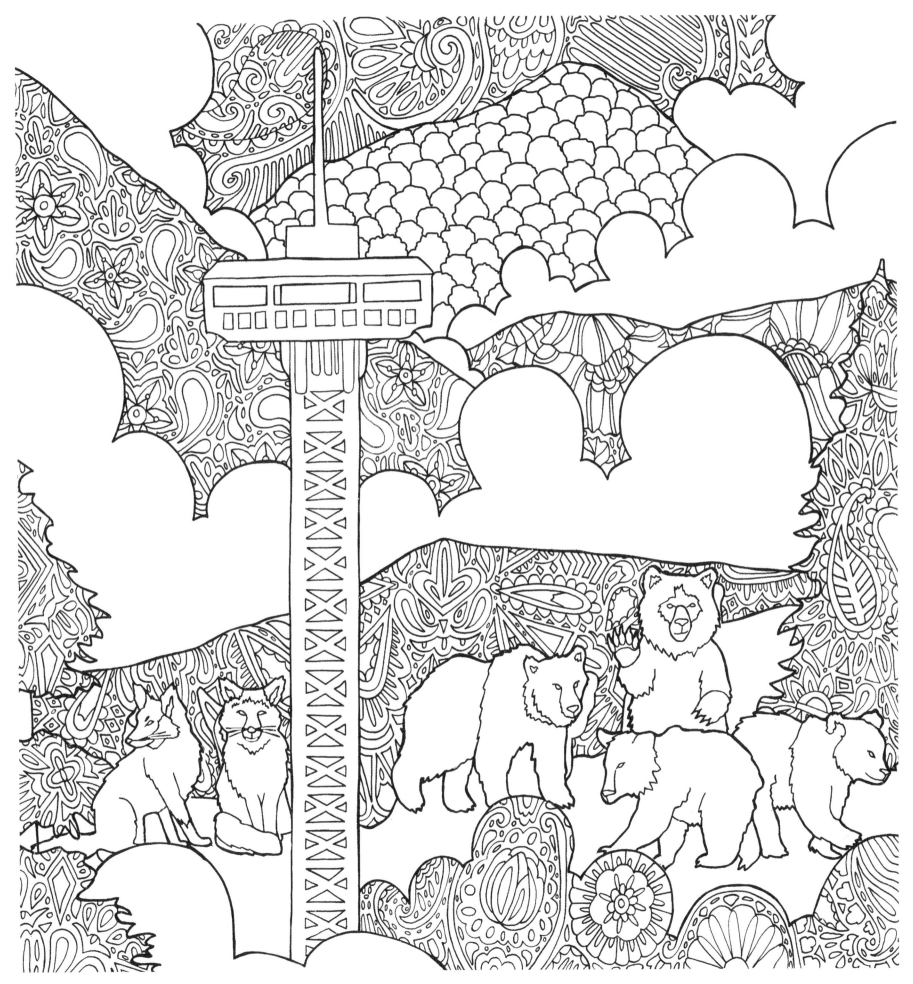

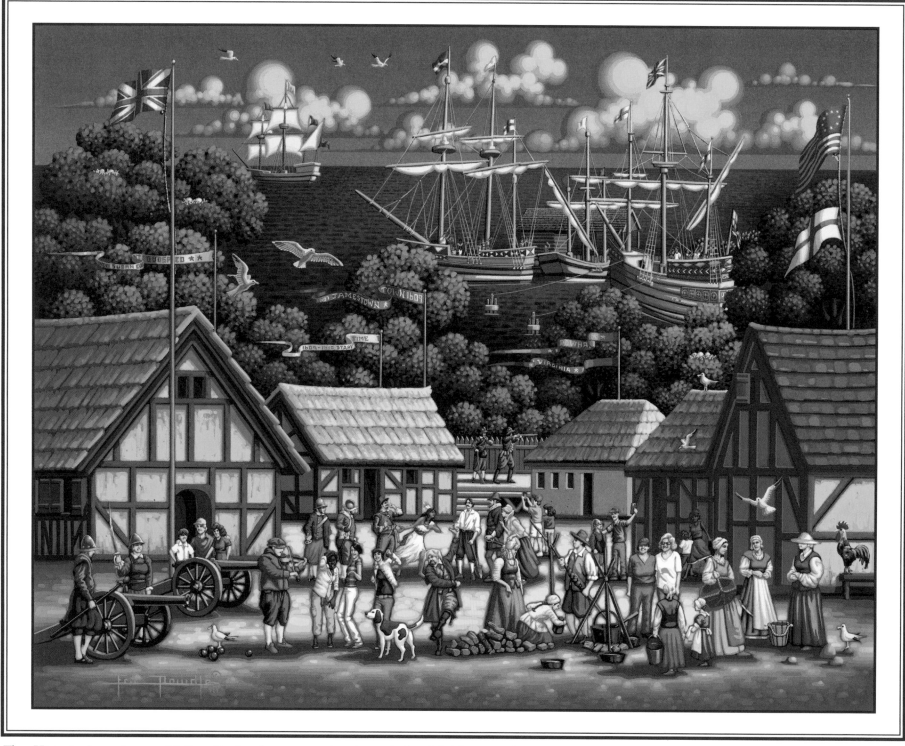

The Historic Jamestowne Visitor Center is a reconstruction of the first English settlement and includes a fort, village and characters in costume. Come walk in the steps of Captain John Smith and Pocahontas

where a successful English colonization of North America began. #DowdleNatlParks #Jamestown

Link to the Story, Video, and Radio Show

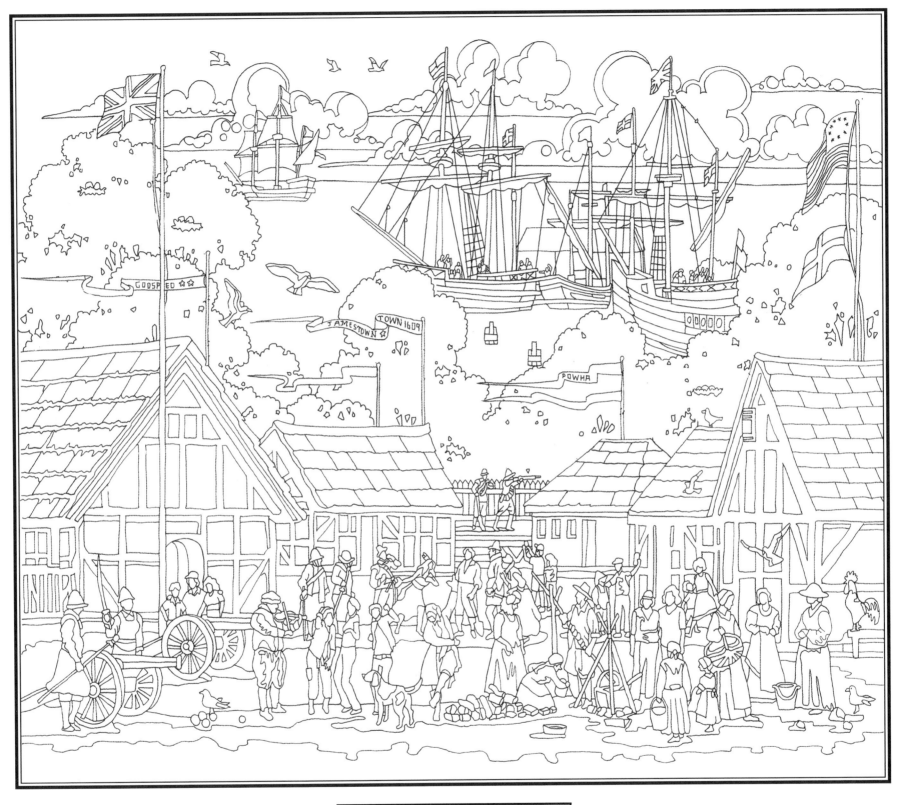

JAMESTOWN

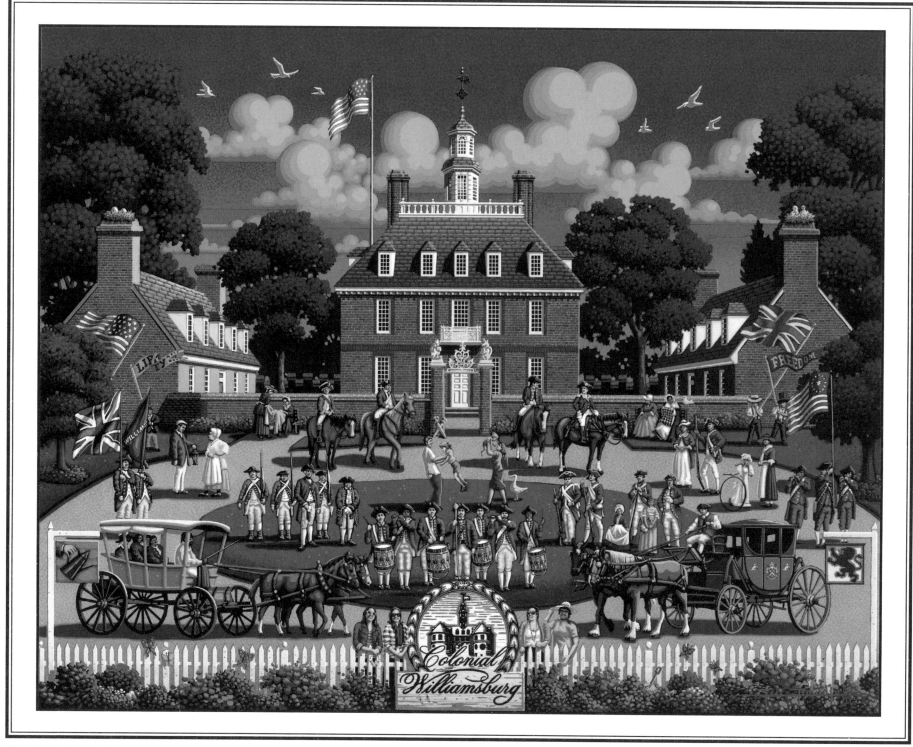

The Colonial Parkway is a twenty-three mile scenic roadway stretching from the York River at Yorktown to the James River at Jamestown. It connects Virginia's historic triangle: Jamestown, Williamsburg, and Yorktown. #DowdleNatlParks #Williamsburg

Link to the Story, Video, and Radio Show

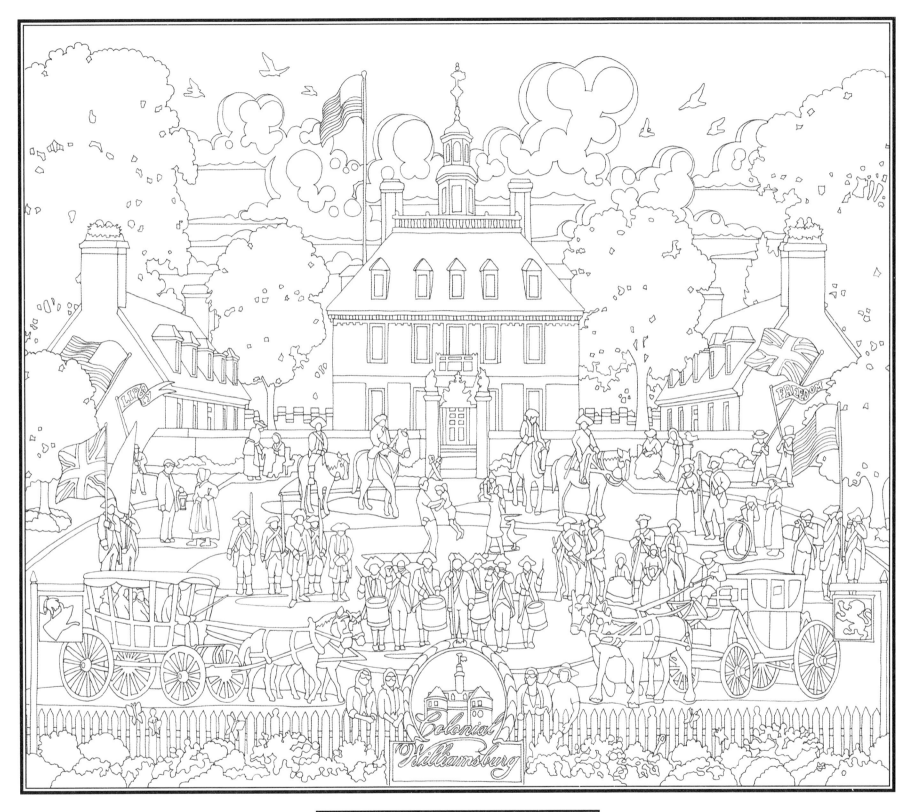

WILLIAMSBURG

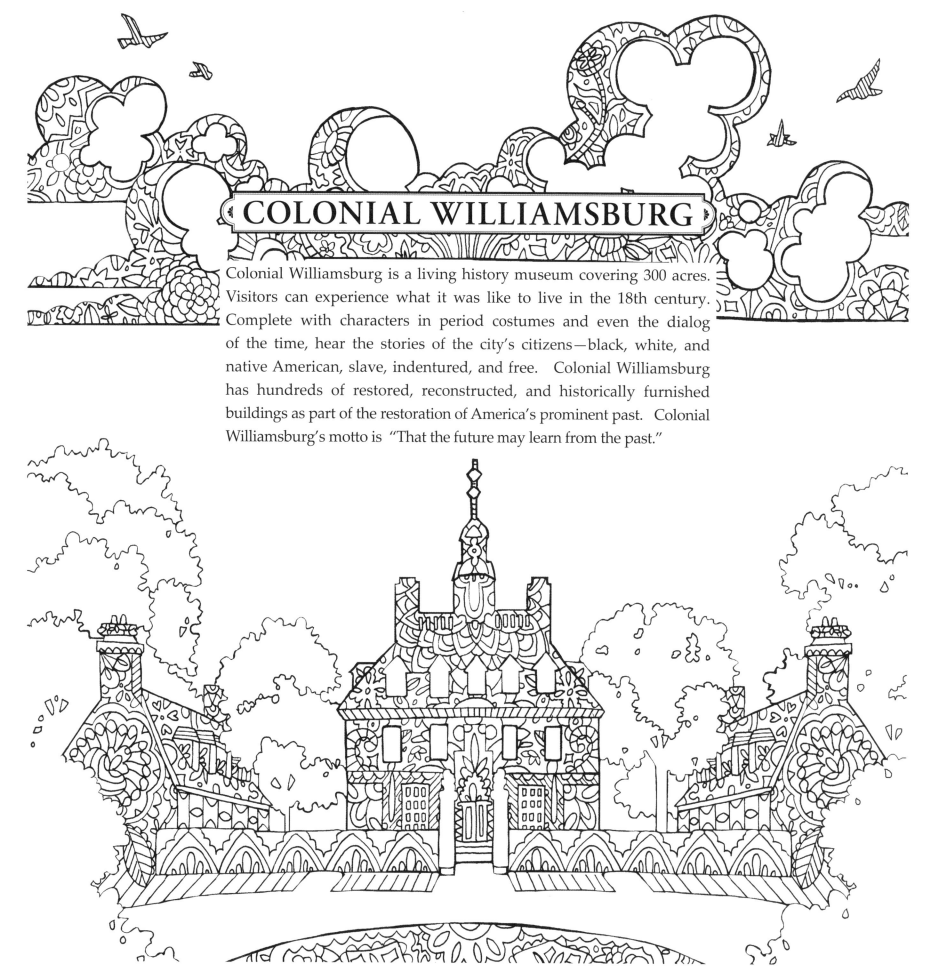

COLONIAL WILLIAMSBURG

Colonial Williamsburg is a living history museum covering 300 acres. Visitors can experience what it was like to live in the 18th century. Complete with characters in period costumes and even the dialog of the time, hear the stories of the city's citizens—black, white, and native American, slave, indentured, and free. Colonial Williamsburg has hundreds of restored, reconstructed, and historically furnished buildings as part of the restoration of America's prominent past. Colonial Williamsburg's motto is "That the future may learn from the past."

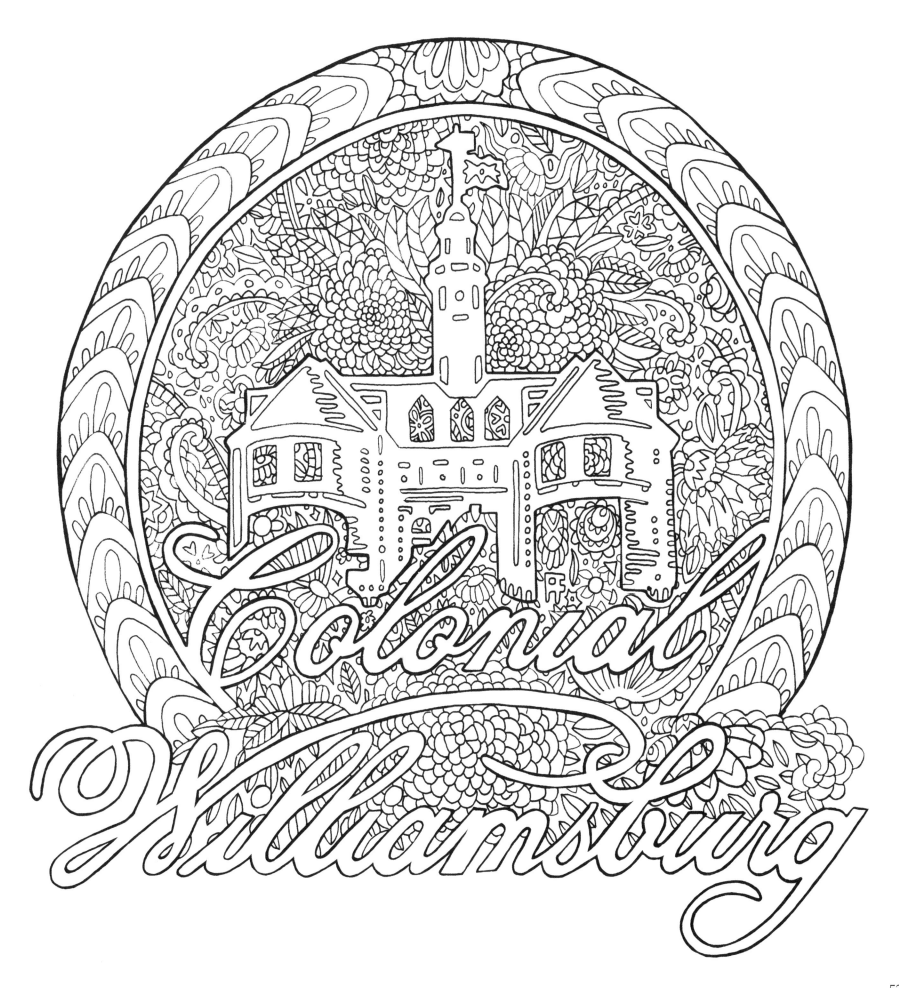

MESA VERDE

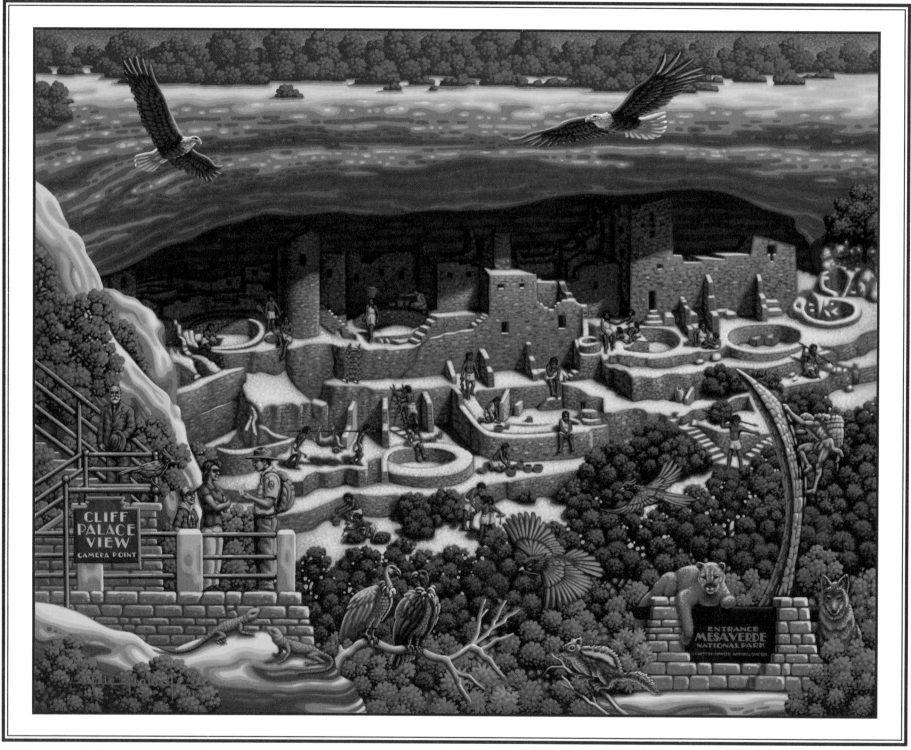

With some of the best preserved Ancestral Puebloan archaeological sites in the United States, Mesa Verde National Park is located in Montezuma County, Colorado. The most famous Hisatsinom ruin, the great cliff dwellings of Mesa Verde tower over the Four Corners area. #DowdleNatlParks #MesaVerde

Link to the Story, Video, and Radio Show

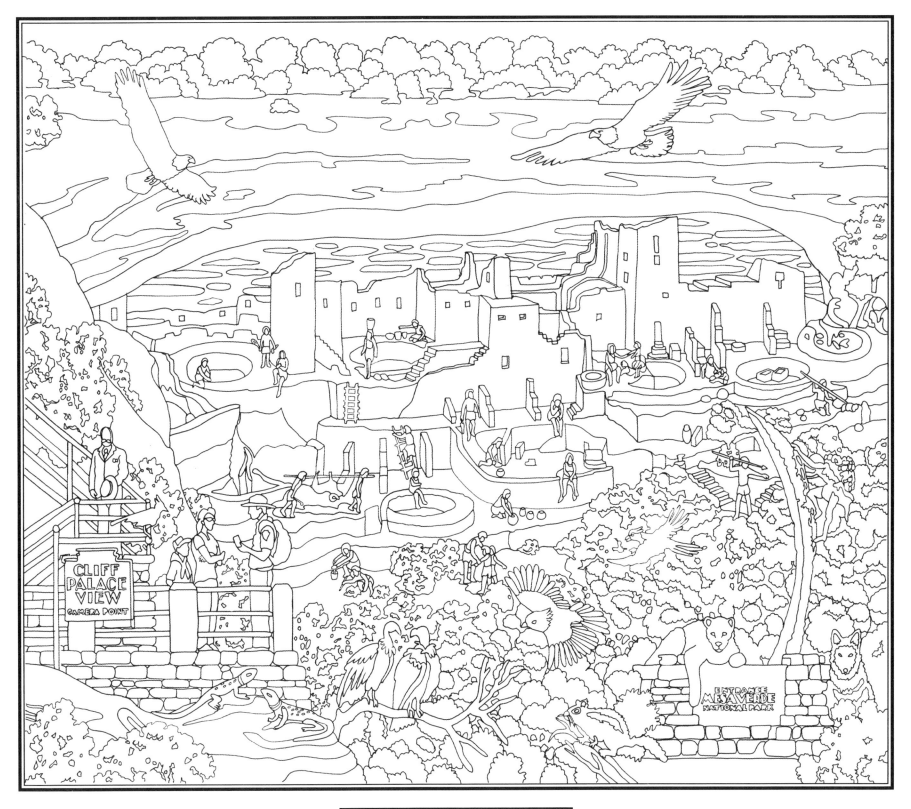

CLIFF
PALACE
VIEW
CAMERA POINT

ENTRANCE
MESA VERDE
NATIONAL PARK

MESA VERDE

YOSEMITE

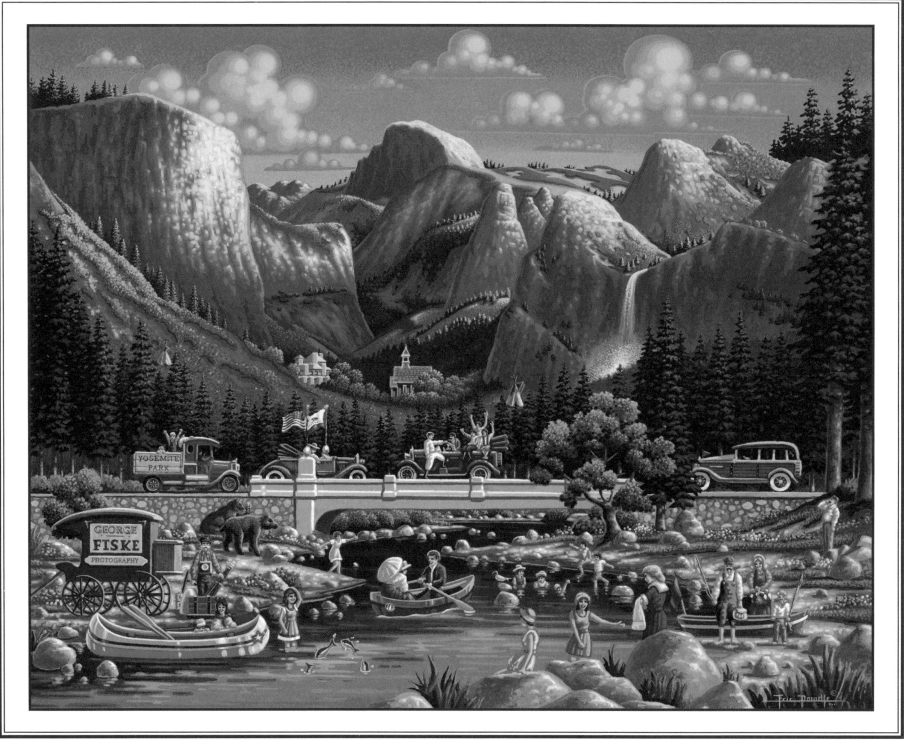

Yosemite, located in Northern California, reaches across the western slope of the Sierra Nevada mountain chain. It is internationally recognized for its spectacular granite cliffs, water falls, clear streams, and giant sequoia groves. Almost 95% of the area is designated wilderness. #DowdleNatlParks #Yosemite

Link to the Story, Video, and Radio Show

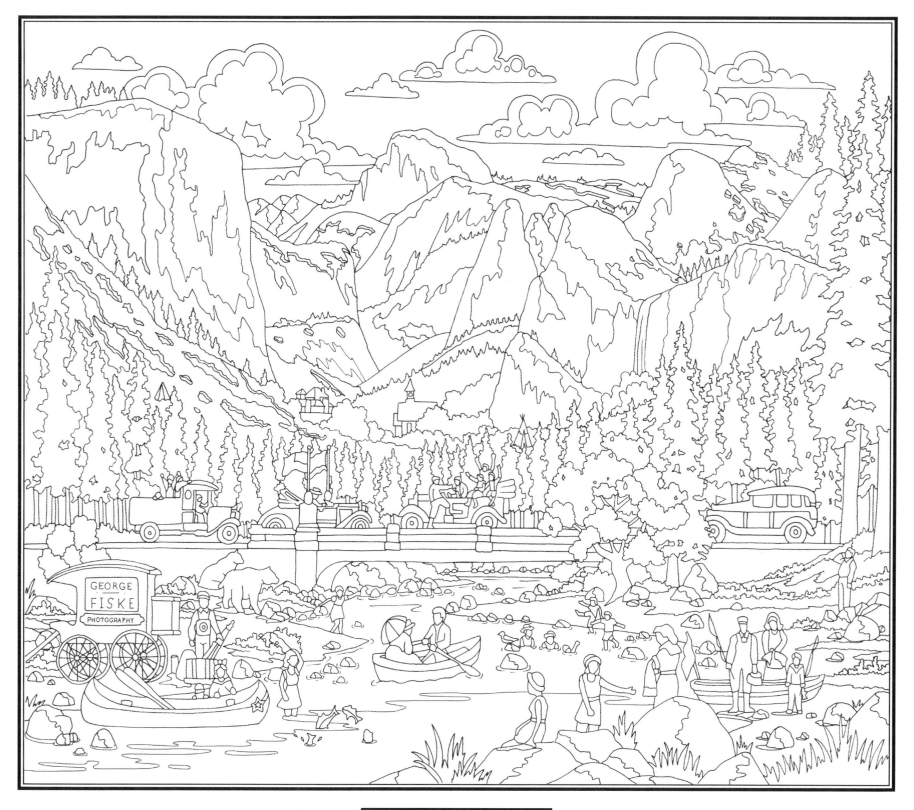

YOSEMITE

YOSEMITE EL CAPITAN

Located in Northern California, Yosemite features one of the largest and least fragmented habitat blocks in the Sierra Nevada and supports a diversity of plants and animals. The name "Yosemite" refers to the name of a renegade tribe which was driven out of the area by the Mariposa Battalion. Before this, the area was called "Ahwahnee" (meaning "big mouth") by the Ahwahneechee Indians. One of the most popular features of Yosemite is El Capitan is a prominent granite cliff that looms over Yosemite Valley. The location is one of the most popular rock climbing destinations in the world due to its wide range of climbing routes as well as its year-round accessibility. Other beautiful features of the high country of Yosemite are beautiful areas such as Tuolumne Meadows, Dana Meadows, the Clark Range, the Cathedral Range, and the Kuna Crest.

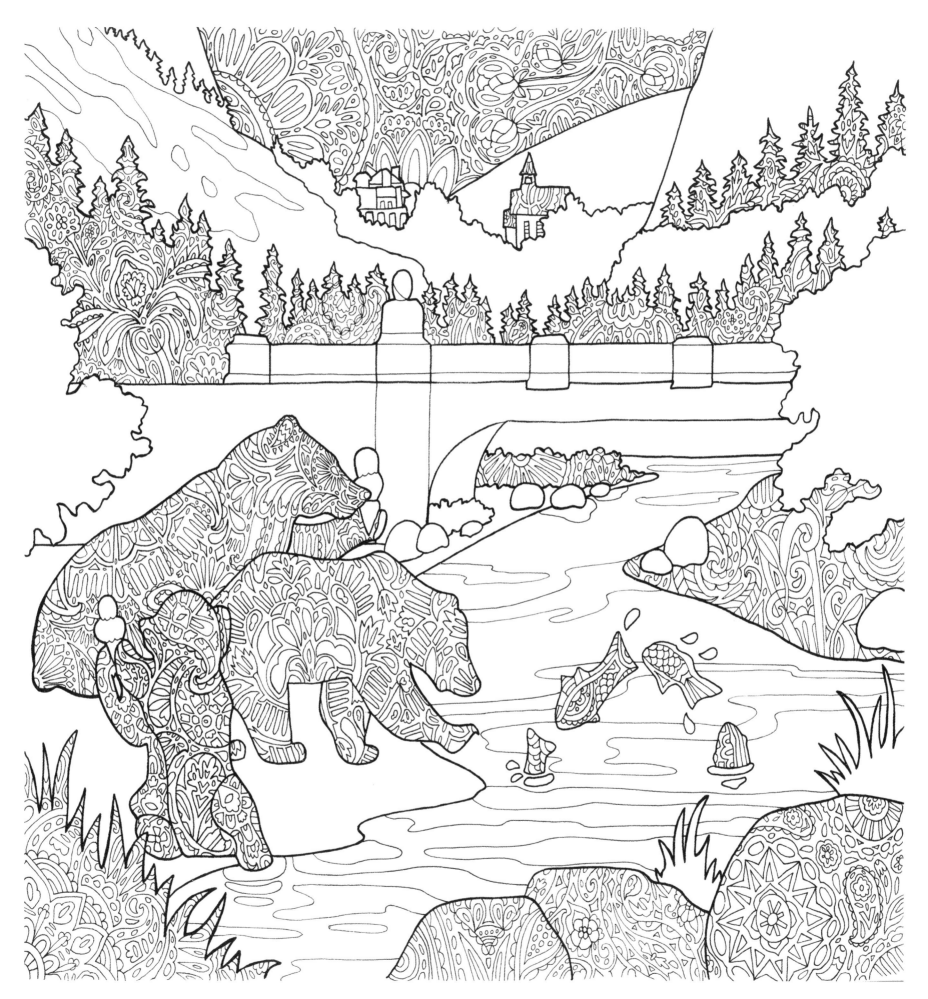

REDWOOD NATIONAL PARK

Home to some of the tallest trees on earth, Redwood National Park also protects vast prairies, oak woodlands, wild riverways, and nearly 40

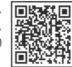

miles of pristine coastline, all supporting diverse wildlife and cultural traditions. #DowdleNatlParks #RedwoodNatlPark

Link to the Story, Video, and Radio Show

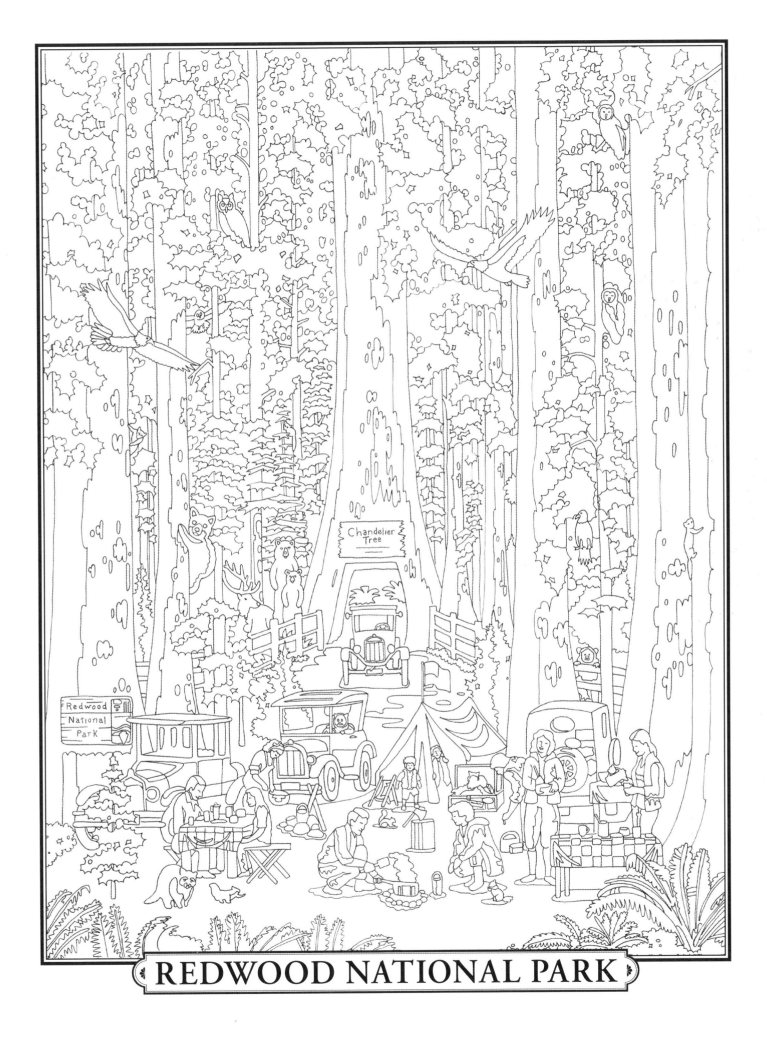

REDWOOD NATIONAL PARK

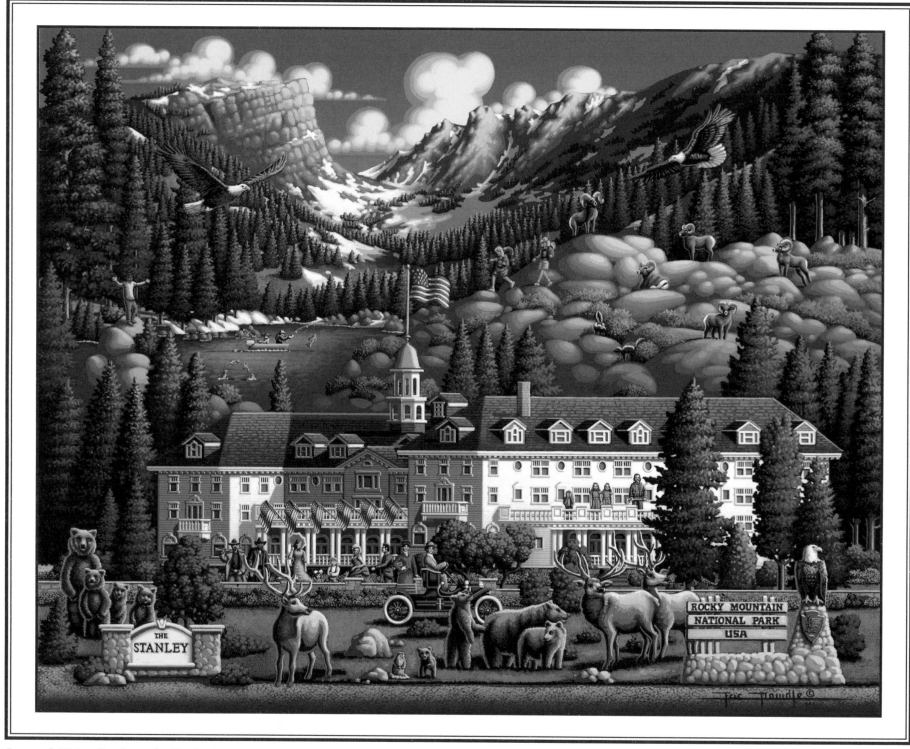

Located 10.4 miles from the Rocky Mountain National Park and 2 miles from Estes Park Golf Course, the Stanley Hotel dates back to 1909. Already known for a haunted history, The hotel was the site for the filming of the movie "The Shining" with Jack Nicholson. #DowdleNatlParks #RockyMountain

Link to the Story, Video, and Radio Show

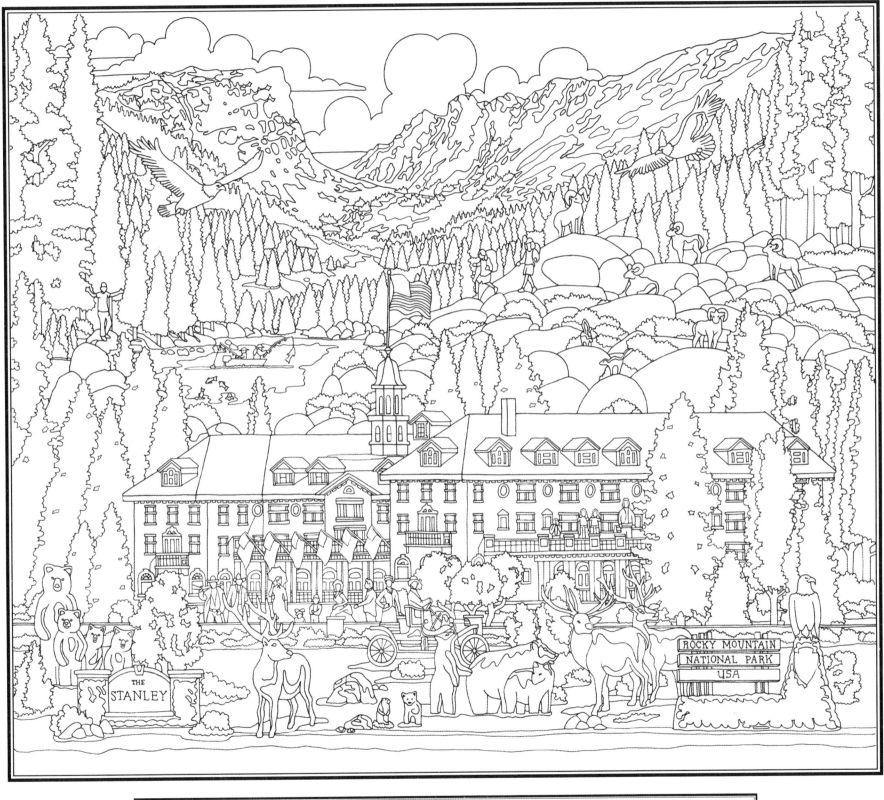

ROCKY MOUNTAIN NATIONAL PARK

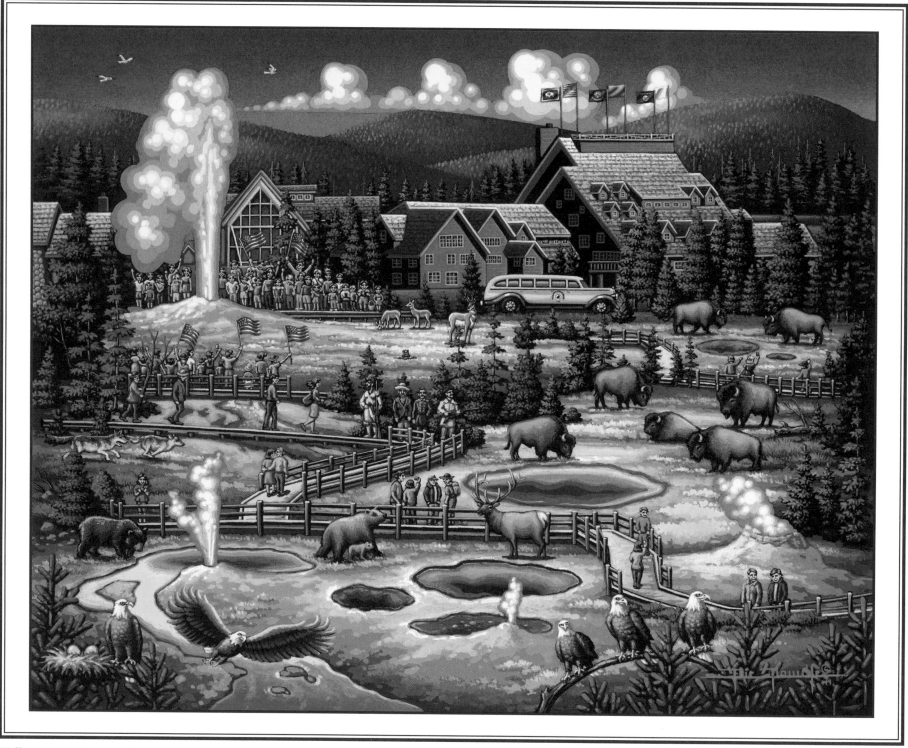

Yellowstone, the first National Park in the U.S. and widely held to be the first national park in the world, is known for its wildlife and its many

geothermal features, especially Old Faithful Geyser, one of the most popular features in the park. #DowdleNatlParks #Yellowstone

Link to the Story, Video, and Radio Show

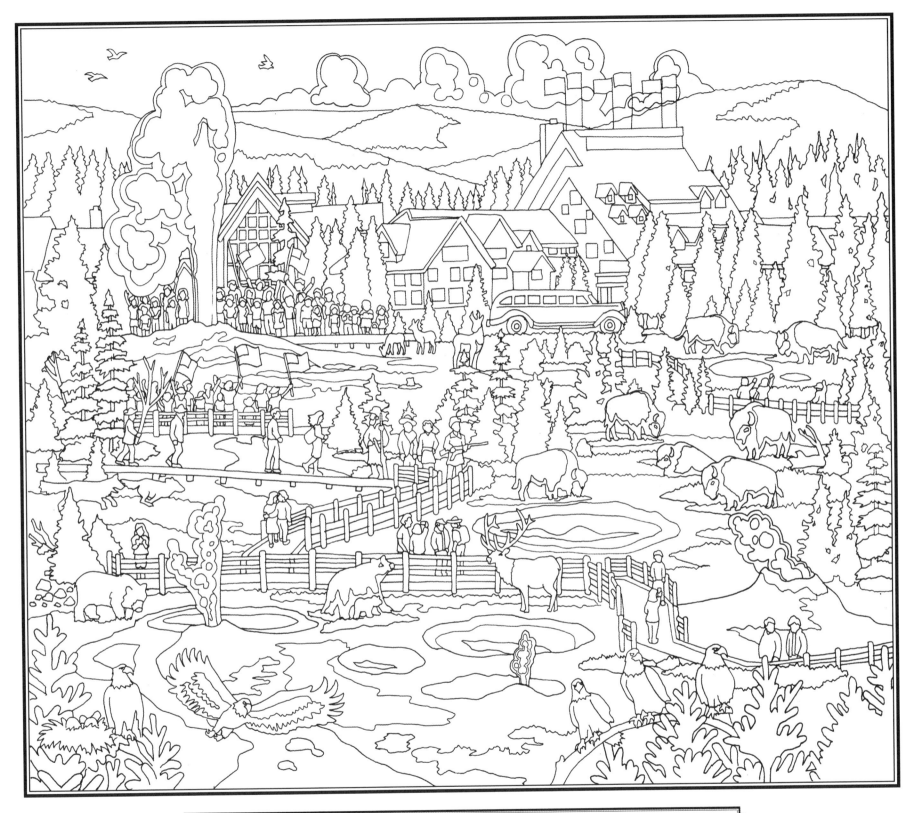

YELLOWSTONE NATIONAL PARK

OLD FAITHFUL GEYSER

Yellowstone National Park is a beautiful and wondrous place. The name was originally taken from French trappers who called it "Roche Jaune" translated literally as "stone yellow," most likely due to the number of yellow stones in the river. The park is known for many features. Perhaps the most well-known is Old Faithful Geyser which erupts approximately every 91 minutes. Yellowstone is also home to many hot springs and a broad range of flora and fauna. One regularly sees deer, bison, and even an occasional black bear. Yellowstone also experiences thousands of small earthquakes every year, many of which are undetectable by people. Yellowstone Lake, one of the largest high-elevation lakes in North America, is centered over the Yellowstone Caldera, the largest super volcano on the continent (and still considered an active volcano!).

SEQUOIA NATIONAL PARK

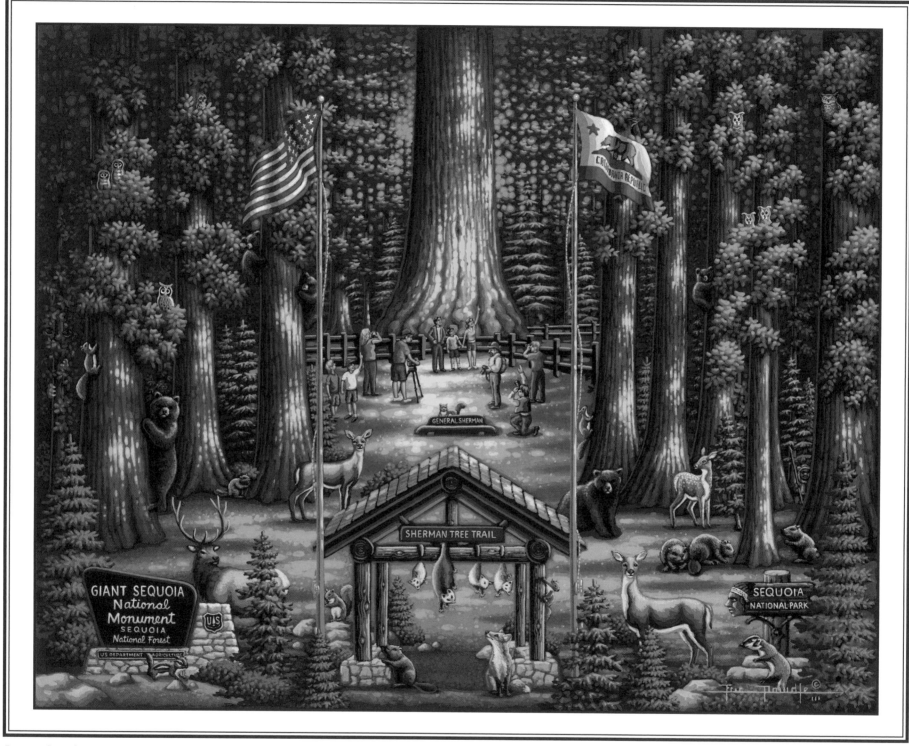

Located in the southern Sierra Nevada mountains of California, Sequoia National Forest is named for the Giant Sequoia trees which populate 38 distinct groves within the boundaries of the forest. #DowdleNatlParks #SequoiaNatlPark

Link to the Story, Video, and Radio Show

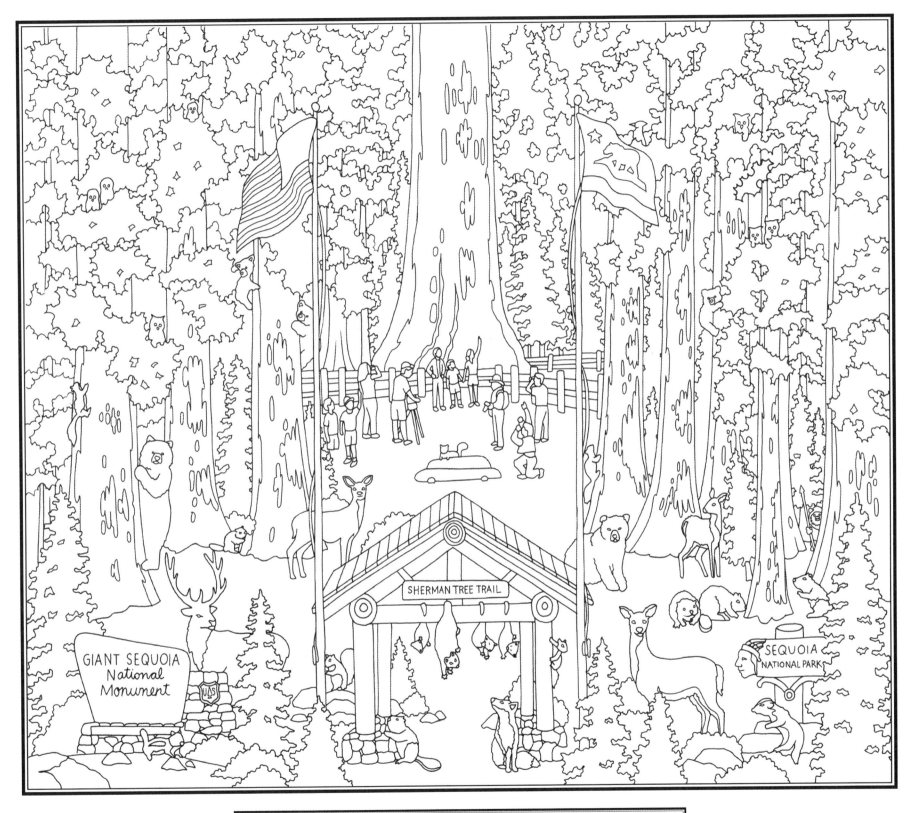

SEQUOIA NATIONAL PARK

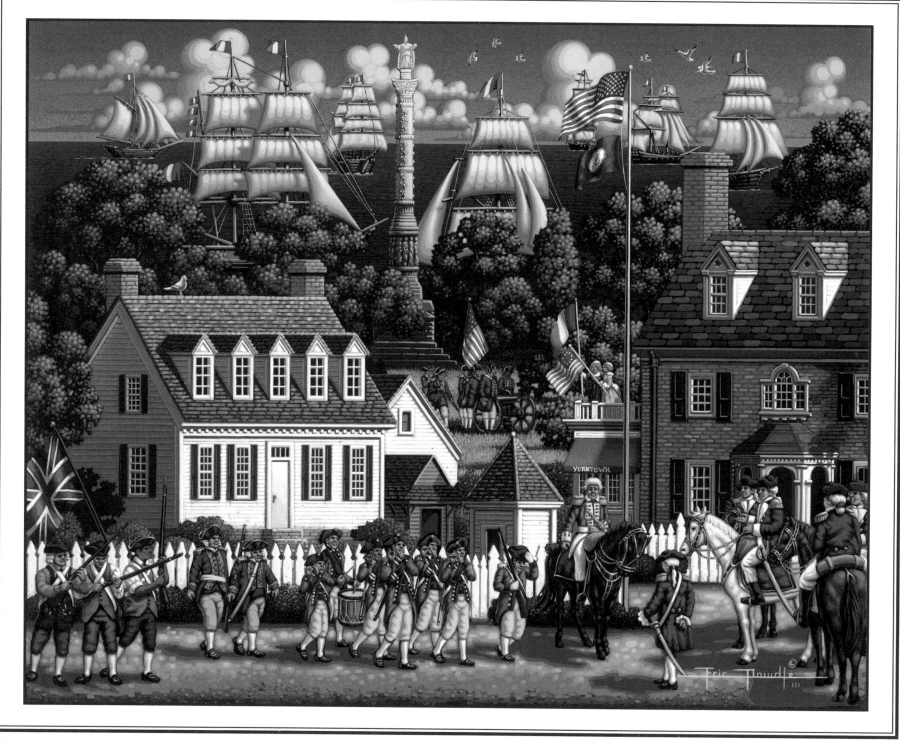

On May 13, 1607, Jamestown was established as the first permanent English settlement in North America. Three cultures came together – European, Virginia Indian, and African–to create a new society that would eventually seek independence from Great Britain. On October 19, 1781,

American and French troops defeated the British at Yorktown in the last major battle of the American Revolutionary War. #DowdleNatlParks #Yorktown

Link to the Story, Video, and Radio Show

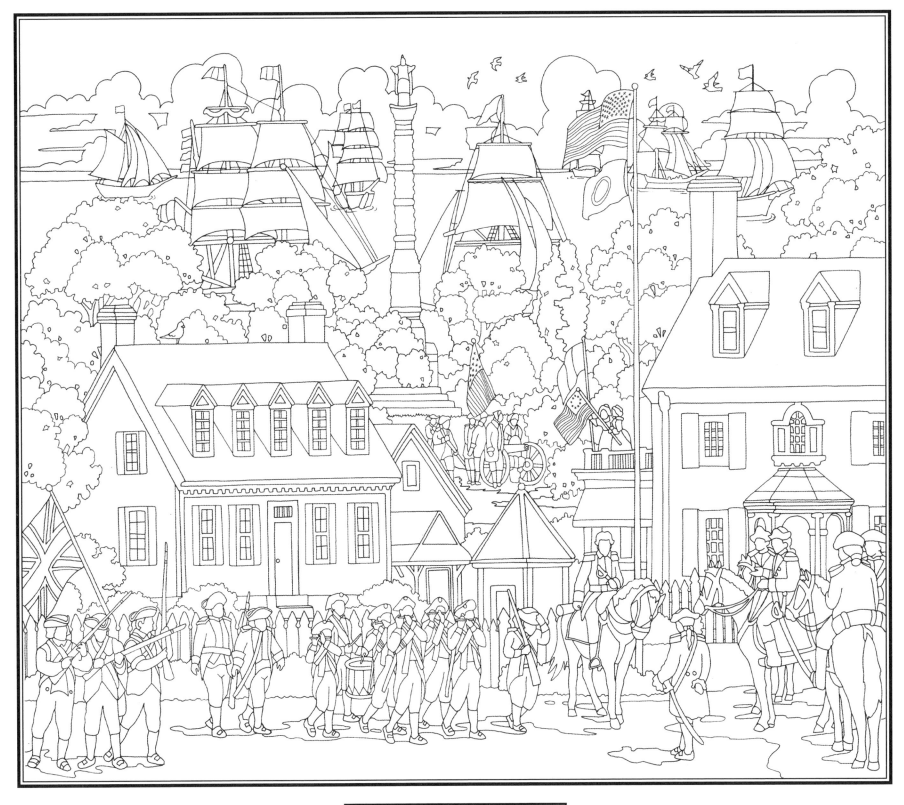

YORKTOWN

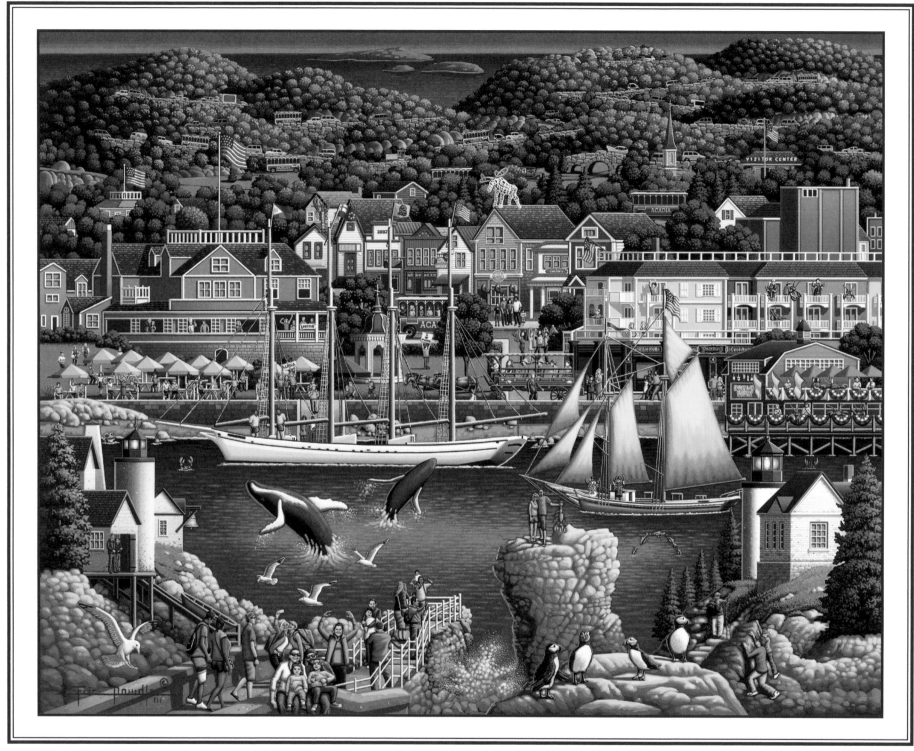

Acadia National Park is located off the Atlantic coast and marked by woodland, rocky beaches, and glacier-scoured granite peaks such as Cadillac Mountain, the highest point on the United States East Coast.

The park is an approximately 47,000-acre recreation area. The bayside town of Bar Harbor, a popular gateway, has many unique restaurants and shops. #DowdleNatlParks #Acadia

Link to the Story, Video, and Radio Show

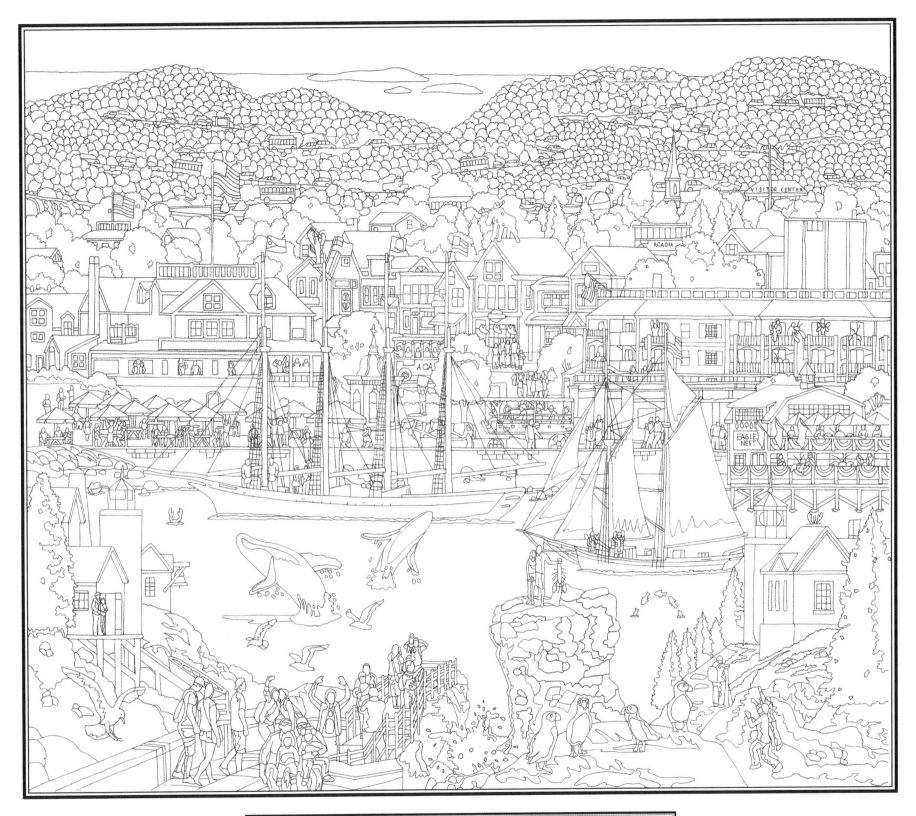

ACADIA NATIONAL PARK

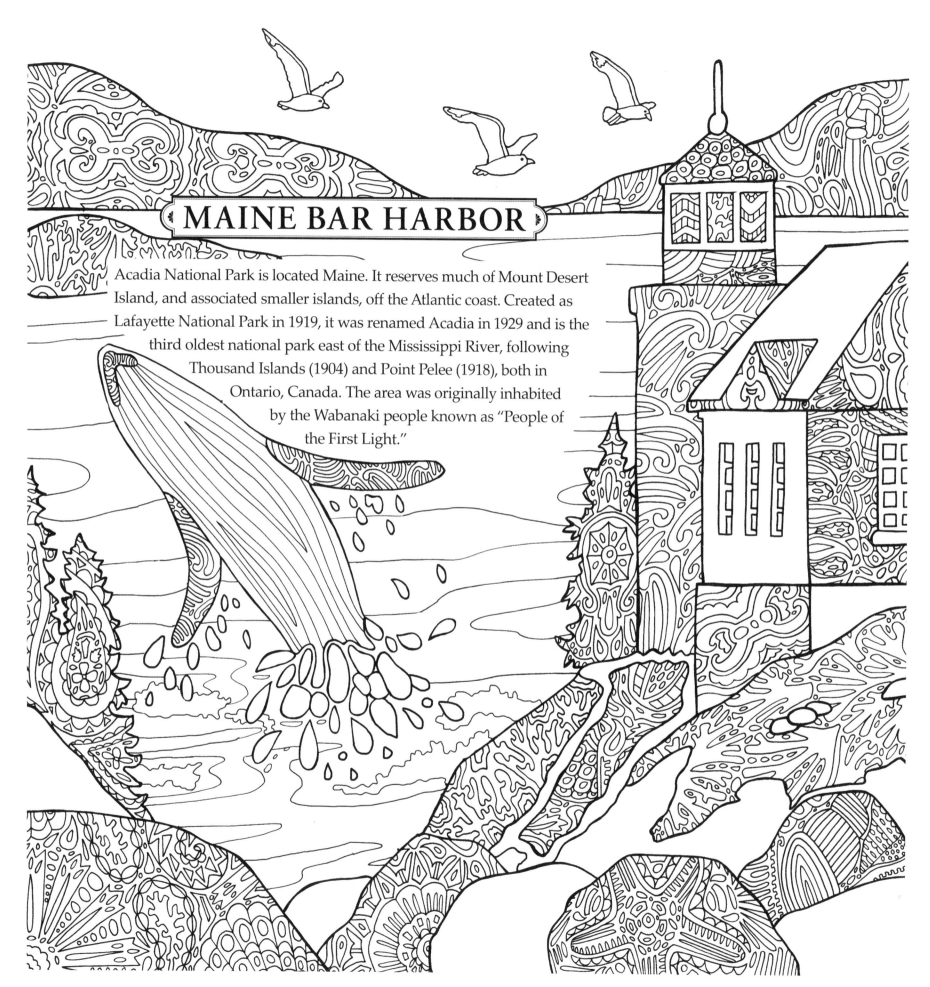

MAINE BAR HARBOR

Acadia National Park is located Maine. It reserves much of Mount Desert Island, and associated smaller islands, off the Atlantic coast. Created as Lafayette National Park in 1919, it was renamed Acadia in 1929 and is the third oldest national park east of the Mississippi River, following Thousand Islands (1904) and Point Pelee (1918), both in Ontario, Canada. The area was originally inhabited by the Wabanaki people known as "People of the First Light."

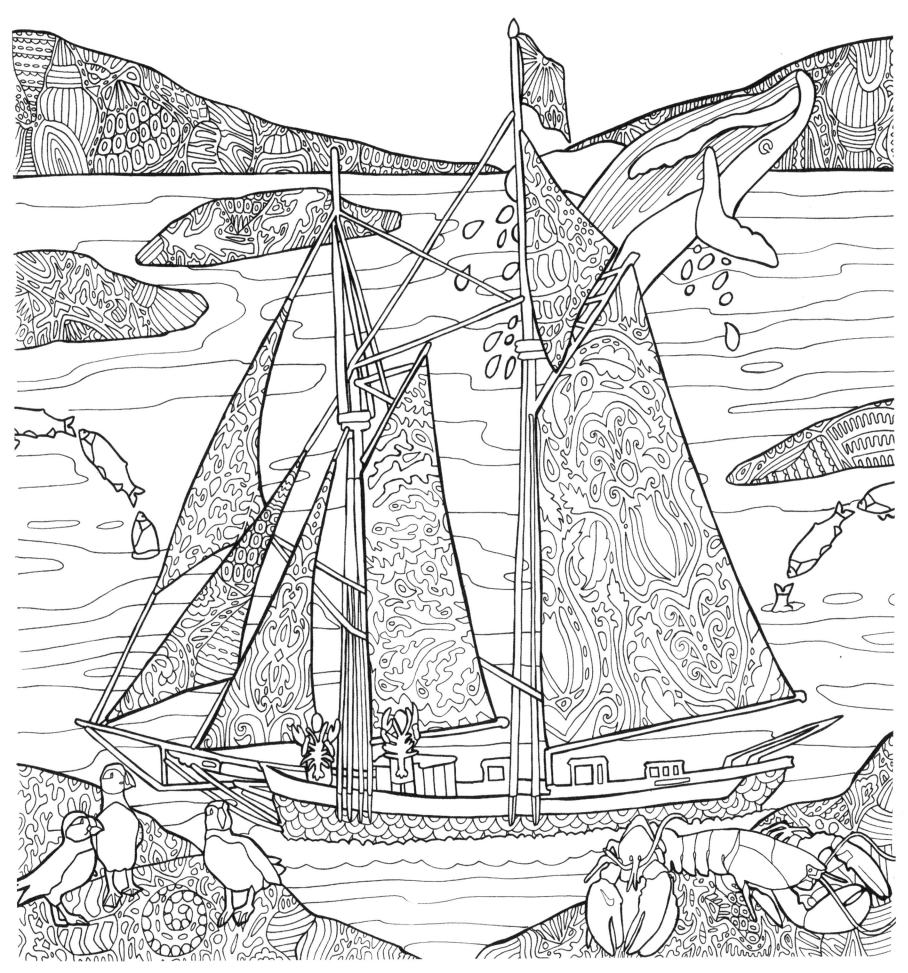